29/04/22

PENGUIN BOOKS

HENRI MATISSE

Photo by Richard Cook

Alastair Sooke is art critic of the *Daily Telegraph* and a columnist for BBC.com. He has written and presented documentaries on television and radio for the BBC, including *Modern Masters, The World's Most Expensive Paintings, Treasures of Ancient Rome* and, most recently, *Treasures of Ancient Egypt*, an acclaimed three-part series about Egyptian sculpture, painting and design. He is a regular reporter for *The Culture Show* on BBC Two, and has presented a number of full-length *Culture Show* programmes about artists including Leonardo da Vinci and Henri Matisse. He is the author of *Roy Lichtenstein: How Modern Art was Saved by Donald Duck*, also published by Penguin. He was educated at Christ Church, Oxford, and at the Courtauld Institute of Art, London. He lives in London with his family.

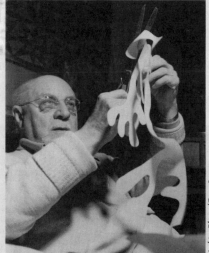

In his final decade, Matisse abandoned painting to make paper cut-outs instead. In this photograph, captured *c.* 1947, he cuts coloured paper in bed at Le Rêve, a villa in the ancient hill town of Vence, where he lived for much of the Forties. Visitors to Vence were frequently startled by the dexterity of his scissor-work.

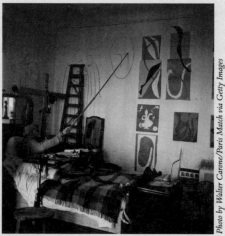

Following his operations, Matisse often worked from bed. Here he uses a charcoal-tipped bamboo pole to draw on the wall of his bedroom-studio at the Hôtel Régina, Nice-Cimiez, in the spring of 1950. Visible to the left are sketches for *Saint Dominic*, one of three major ceramic murals decorating the interior of the Chapel of the Rosary at Vence.

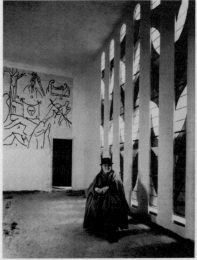

Matisse considered the Chapel of the Rosary at Vence his 'masterpiece'. In this photograph, taken in 1950 when the chapel was not yet finished, he sits in between the *Way of the Cross* ceramic mural and the stained-glass windows running along the southern wall of the nave. The chapel would be consecrated the following summer.

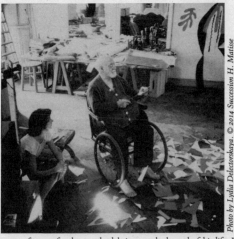

Matisse was often confined to a wheelchair towards the end of his life. Yet, despite physical infirmity, he enjoyed a miraculously productive year in 1952, when his assistant Lydia Delectorskaya took this picture documenting the appearance of his studio at the Hôtel Régina, Nice-Cimiez. An early state of his cut-out *The Negress* is visible on the wall in the background.

Henri Matisse

A Second Life

ALASTAIR SOOKE

PENGUIN BOOKS

PENGUIN BOOKS

Published by the Penguin Group
Penguin Books Ltd, 80 Strand, London WC2R ORL, England
Penguin Books (USA) Inc., 375 Hudson Street, New York, New York 10014, USA
Penguin Group (Canada), 90 Eglinton Avenue East, Suite 700, Toronto, Ontario,
Canada M4P 2Y3 (a division of Pearson Penguin Canada Inc.)
Penguin Ireland, 25 St Stephen's Green, Dublin 2, Ireland (a division of Penguin Books Ltd)
Penguin Group (Australia), 707 Collins Street, Melbourne,
Victoria 3008, Australia (a division of Pearson Australia Group Pty Ltd)
Penguin Books India Pvt Ltd, 11 Community Centre,
Panchsheel Park, New Delhi – 110 017, India
Penguin Group (NZ), 67 Apollo Drive, Rosedale, Auckland 0632,
New Zealand (a division of Pearson New Zealand Ltd)
Penguin Books (South Africa) (Pty) Ltd, Block D, Rosebank Office Park,
181 Jan Smuts Avenue, Parktown North, Gauteng 2193, South Africa

Penguin Books Ltd, Registered Offices: 80 Strand, London WC2R ORL, England

www.penguin.com

First published 2014
002

Printed in Great Britain by Clays Ltd, St Ives plc

ISBN: 978-0-241-96908-3

www.greenpenguin.co.uk

MIX
Paper from
responsible sources
FSC
www.fsc.org FSC™ C018179

Penguin Books is committed to a sustainable
future for our business, our readers and our planet.
This book is made from Forest Stewardship
Council™ certified paper.

For Milena

Contents

I
Resurrection

One January morning in 1941, only a fortnight or so after his seventy-first birthday, the bearded and bespectacled French artist Henri Matisse was lying in a hospital bed, preparing to die. During the previous year he had soldiered on despite suffering recurring abdominal cramps, which had plagued him on and off throughout his life. Following the discovery of a tumour, though, he had decided to take a twelve-hour train ride, against the advice of his doctors, from a hospital in Nice, on the Côte d'Azur, to the Clinique du Parc in Lyon. It was a perilous journey north in midwinter, towards territory occupied by German troops, but Matisse had embarked upon it at the insistence of his strong-willed daughter, Marguerite. He required a skilful physician who could perform colonic surgery, and one of Marguerite's friends had recommended Professor Wertheimer in Lyon. Following a prompt examination with two colleagues, and a diagnosis of possible duodenal cancer, Wertheimer booked in his frail new patient, whose problems were compounded by a weak heart, for an emergency operation on 16 January, a week after his arrival in the city.

'I am about to have a little operation,' the painter wrote to his second son, Pierre, who was by then an art dealer in New York, shortly before the procedure. 'I am not at all afraid. In fact, I feel completely detached from the whole affair. I do not think that my operation is a dangerous one.' But he was downplaying the risks in order to stave off Pierre's anxiety. Five days earlier, he had composed a brisk will on a single sheet of paper that divided his estate equally between his three children: Pierre, Pierre's older brother, Jean, and Matisse's first child, Marguerite. Matisse was in no doubt that his life was under threat. Although he had travelled extensively, to Moscow, Morocco, America and even Tahiti, his operation in 1941 was, as he put it later, 'the biggest journey I've ever made' – and he wasn't sure he would return. 'I was ready to die,' he said.

In a two-stage colostomy, with the second part performed four days after the first, his surgeons cut away 14 inches of diseased intestine, leaving Matisse almost fatally enfeebled. He convalesced at the clinic, effectively 'in solitude', he said, for three months. 'I received only ten visits and I didn't ask for any of those,' he recalled soon afterwards, in conversation with the Swiss art critic Pierre Courthion. Every day, one of the surgeons who had saved his life, René Leriche, dropped by in between operations, telling Matisse stories to cheer him up and bringing him prunes from the clinic's kitchens. Otherwise Matisse was lost in 'a sort of lucid delirium', tormented by 'the most appalling pain', which

he continued to suffer 'night and day for a very long time'.

His situation was not helped by complications following the operations. On 22 January, he had a pulmonary embolism, which almost killed him. So did a blood clot on his lung in early March. When the pain became particularly intense, he would turn to one of the nuns running the clinic and say: 'And according to you there's still hell, even after that?' At points, he confided to Courthion, 'I wondered if it wouldn't be better to die than to suffer like that.'

Despite all this hardship, though, Matisse refused to give up. 'In those little moments of calm, between two pangs,' he recalled, 'I imagined the inside of a tomb: a little space, completely enclosed, with no doors. And I told myself, "No, I prefer still being around even if it does mean suffering!"' By his side he had his resilient daughter, Marguerite, who was now forty-six years old. Marguerite had supported her father, who adored her and often solicited her judgement of his paintings, ever since her time as a studio child in Paris, when Matisse's family was still impoverished. During those difficult early days, back in the summer of 1901, Matisse had held down Marguerite upon the kitchen table while a doctor performed an emergency tracheotomy in order to ease breathing difficulties caused by diphtheria. She was then only six years old. To mask the resulting 3-inch scar, Marguerite wore a black ribbon round her neck. Four decades later, it was her turn to

assist her father during the fraught moments surround-
ing another traumatic, life-threatening operation. She
remained at his bedside in Lyon for three months.

Along with Marguerite, a second woman also kept
watch over Matisse: Lydia Delectorskaya, his model, sec-
retary, studio manager and housekeeper. Born in Siberia,
'Madame Lydia', as Matisse always called her, was an
extraordinarily intelligent blonde former film extra.
Pierre later described her as 'the green-eyed dragon'. Her
presence in Matisse's life since the early Thirties had pre-
cipitated the disintegration of his marriage to his wife,
and Marguerite's stepmother, Amélie, from whom he
had separated two years earlier, in March 1939. 'It's
me or her,' Amélie had supposedly told her husband,
and Matisse chose Lydia, whom he considered 'indis-
pensable'.

Bit by bit, Matisse edged back from death, but the
effort of doing so often put him in a foul temper. 'I am
so awful to them [Marguerite and Lydia] that they each
go off into a corner of their own and cry their eyes
out,' he told Pierre. ' "It's because he's so ill," they say
to one another. "He's never been like this before." '
Eventually Matisse was strong enough to visit the
nearby parc de la Tête d'Or. There, perhaps while
wearing his best suit of reddish tweed, which was thick
enough to keep him warm, he tentatively walked beside
a pretty lake, and exulted in a magnificent thicket of
magnolia trees in blossom that seemed to herald not
only seasonal change but also the springtime of his
recovery. On his return to the clinic, he told one of the

sisters that 'the mass of trees, all leafless but in blossom, was like the Virgin's cloak. She looked at me, surprised and flattered.' Cheered that Matisse could once again find beauty in the world around him, the nuns in the clinic gave him a nickname: Le Ressuscité, or the man who rose from the dead.

On 1 April, Matisse moved to the Grand Nouvel Hôtel in Lyon, where he remained until late May. 'It's been a terrible business, my dear Pierre,' he said on 2 May, nearly four months after he had gone under the knife, substituting honesty for the misleading confidence of his last letter to his son. 'It was immensely painful, and I was resigned to the idea that I would never get off the operating table alive. So now I feel as if I had come back from the dead. It changes everything. Time present and time future are an unexpected bonus.'

Of course, there were privations. Matisse was now an invalid. The operations permanently weakened his abdominal muscles, which meant that he could no longer stand upright for extended lengths of time, and was often compelled to use a wheelchair. He also had to wear what he called a 'special belt' – a humiliating girdle made of metal and rubber. Gallbladder infections coupled with chronic insomnia ensured that he was frequently bedridden. 'I am a mutilated man,' he told Pierre.

Yet, in letters to lifelong friends, such as Charles Camoin, with whom he had studied in Paris during the 1890s, Matisse said that he once again felt young: 'I feel

so healthy, these days, that it scares me.' On the anniversary of his ordeal in Lyon, Matisse told the French painter Albert Marquet, another friend from his student days, that he had been granted 'a second life'. Two months later, he said the same thing to Pierre: 'It's like being given a second life, which unfortunately can't be a long one.' Matisse was jubilant that he had survived, but he was also conscious that every day could be his last.

He was concerned, too, that he would never paint again. 'If only I can do some good work again I shall be happy,' he confided to Pierre. By now, his standing as one of the masters of Modernism was assured. A decade earlier, in 1931, he had already been honoured with a retrospective of almost eighty paintings, as well as eleven sculptures, at the Museum of Modern Art in New York. An international celebrity, he was routinely lionized as the leader of 20th-century painting, along with his friend and rival Pablo Picasso, who was nearly twelve years younger than him. It was said that when Matisse and Picasso met, as they did over the summer of 1913, when they often went horse riding together in the forest of Clamart south-west of Paris, it was like the rulers of sparring kingdoms coming together for a diplomatic summit. Following his operations, then, Matisse was anxious that his infirmity would give Picasso the upper hand.

Matisse had asked his doctors in Lyon for a respite of three years 'in order to bring my work to a conclusion'. In the end, his resurrection lasted much longer. On

23 May 1941, Matisse arrived back in his double apartment on the seventh floor of the old Hôtel Régina, now a large block of flats in Cimiez, a suburb of Nice on a hill looking down on to the city and the Bay of Angels, where he had lived since the autumn of 1938. He would survive for another thirteen years. With every year that passed, Matisse sent his surgeon Leriche a book or a drawing as a gift to say thank you for having miraculously prolonged his life. Yet the extent of Matisse's second life was less surprising than the spellbinding transformation of his art that took place while it lasted.

Matisse's final decade was arguably more prodigious than any other period of his magnificent career, which endured for more than sixty years and produced countless masterpieces from the time of his revolutionary Fauvist paintings *The Woman with the Hat* (1905) and *The Joy of Life* (1905–6). In his last years, in defiance of his deteriorating physical condition, Matisse developed a thrilling new method of making art using scissors and painted sheets of paper that allowed him to work with brilliant colours even when he was bedbound. It would become one of the most radical and unprecedented inventions of any artist of the 20th century. In an astonishing burst of creativity, he produced hundreds of new works in his seemingly effortless late style that came to be known as his 'paper cut-outs'. Many of them were colourful models for creations in other mediums, including magazine, catalogue and book covers, wall-hangings, tapestries, a rug, stained glass, and even scarves and liturgical vestments. Here was a valedictory flourish

worthy of Old Masters such as Titian, who also found great freedom of expression towards the end of his life – and Matisse knew it. In a letter written in April 1952, he described his fabulous composition *Sorrow of the King*, which he had recently finished, as 'equal to all my best paintings'. He was eighty-two years old.

This book tells the extraordinary story of how Matisse returned from the grave, abandoned his paintbrushes in favour of scissors and embarked upon his artistic 'second life'. Matisse, who believed that 'the creators of a new language are always fifty years ahead of their time', knew immediately that the sort of art he was making had never existed before. 'The importance of an artist is to be measured by the number of new signs he has introduced into the language of art,' Matisse told his friend Louis Aragon, the French poet and novelist, in 1942. Given the profusion of colourful new signs that fell from the blades of his scissors towards the end of his life, Matisse was a very important artist indeed.

2

Jazz

Matisse first picked up a paintbox and brush while con-
valescing from appendicitis when he was twenty years
old. 'From the moment I held the box of colours in my
hand, I knew this was my life,' he said later, comparing
himself to 'an animal that plunges headlong towards
what it loves'. In the decades that followed, he enjoyed
many remarkable years as an artist, when his creativity
operated more keenly than ever before. One such period
was the famous summer that he spent with his wife,
Amélie, and the artist André Derain in the obscure Cata-
lan seaport of Collioure in 1905. The bold paintings that
he and Derain made there – exploding with colours like
'sticks of dynamite . . . primed to discharge light', in the
words of Matisse's younger artist-comrade – scandalized
the Parisian art world when they were shown at the
Salon d'Automne that October. This was the famous
exhibition that marked out Matisse as the alpha male of
a pack of 'Fauves', or 'wild beasts', since his canvases
seemed so ferocious.

Over the next decade, indeed up to the penultimate
year of the First World War, when Matisse arrived for
the first time to spend a season painting in Nice, there

were many more breakthroughs. In 1910, for instance, he completed his sensational panels *Dance (II)* and *Music*, in which fearsome vermilion figures occupy vast green plains beneath fathomless blue skies. The year after that, inspired by an exhibition of Islamic art that he had seen in Munich the previous October, he executed four brilliant and elaborate paintings described by the American art historian Alfred Barr as Matisse's 'Symphonic Interiors'. The sumptuous climax of the series, *The Red Studio*, presents the contents of Matisse's workplace, including paintings, sculptures, pieces of furniture, a box of crayons, a wine glass and a grandfather clock, all adrift in a great sea of sensual red. 'You're looking for the red wall,' Matisse would tell visitors baffled by the appearance of his actual studio, which was painted white. 'That wall simply doesn't exist.' In saying this, he was emphasizing his chief achievement as a painter. Like many of Matisse's canvases, *The Red Studio* dismantled the classical tradition of painting, which for centuries had sought to replicate the appearance of the world, and replaced it with a more modern mode of art privileging subjectivity and self-expression. *The Red Studio* ended up in New York, where it acted as an important catalyst for the younger generation of painters who would become known as the Abstract Expressionists. Yet it was the moment when Matisse began cutting simple figures out of colourful sheets of paper in the early Forties that might be considered the greatest of his career.

After returning to Nice in May 1941, Matisse slowly

eased his way back into work. That summer, he started to paint again and began a series of bold still lifes, culminating in *Still Life with a Magnolia*. In June, he reported to Pierre that he was 'very happy'. Despite the war, he found that he could 'enjoy an absolute tranquillity': he especially liked to walk in a garden near his apartment in the white-marble Régina, a former imperial hotel patronized by Queen Victoria in the 1890s. Indeed, the war did not intrude much upon his simple life, although it did make it difficult to obtain the lemons and flowers that he wished to paint: 'Still lifes used to cost nothing to put together, but now they are either out of the question or more expensive than a beautiful woman,' he said.

That August, Matisse was visited by the courageous American journalist Varian Fry, who photographed him halfway up a stepladder, wearing dark, thick-framed glasses and comfortable white trousers, and finessing the top left corner of *Nymph in the Forest*, an enormous, incomplete canvas on which he had been working since 1935. Fry was an agent for the Emergency Rescue Committee, which helped people who wished to flee Nazi persecution, and he tried to persuade Matisse to leave France and shelter in America until the war was over. Matisse refused. 'If everyone of any worth leaves the country,' he used to say, 'what will become of France? I should feel myself a deserter, if I left.' With the upheaval of Lyon still fresh in his mind, Matisse did not want to leave Nice again so soon. But before long his tranquillity would be destroyed.

Frustrated by his inability to find any rhythm in his painting, he wrote grumpily to Marguerite in May 1942: 'This year is a write-off.' That was before the agonies of a gallstone in his bladder kept him bedridden and unable to work until the middle of August. On occasion, not even morphine could relieve his pain.

Then, in 1943, after the Allies took control of North Africa, Nice became a potential target for bombardment. That March, an air raid at Cimiez, where the Régina was one of the most conspicuous buildings in the suburb, prompted Matisse to consider evacuation. At the end of June, he left the city, and went to live in a villa called Le Rêve on the outskirts of Vence, an ancient inland hill town a few miles west of Nice. Some of his friends were snooty about Le Rêve, which was modestly proportioned and not especially picturesque. But Matisse, who initially rented the house for only a year, enjoyed living there so much that it became his principal residence until 1949. As the French photographer Henri Cartier-Bresson documented in pictures taken in Le Rêve between 1943 and 1944, Matisse found pleasure there while sketching his white Milanese pigeons, which were allowed out of their cages. He had collected caged birds since 1936, and was devastated when a pair of beloved song thrushes in his aviary, which at one point boasted nearly 300 rare birds, died soon after his return to Nice following his operations.

Above all, Matisse found peace in Le Rêve's garden, which was situated across a terrace and down some

steps from his room on the ground floor. This sloping patch of greenery was filled with orange, palm and lemon trees, as well as the pomegranate fruits and curling philodendrons that would inspire many of the undulating forms of his later paper cut-outs. A documentary film directed by François Campaux in 1946 shows Matisse walking through his garden in Vence, wearing a scarf, hat and greatcoat to protect him against the cold. In one memorable sequence, the artist plucks a small flower and then draws it on the spot, while still standing up. For Matisse, sketching flowers and trees held almost spiritual significance. His garden at Vence was a private Arcadia in which he loved to observe the natural world. There, he could foster an artistic innocence that was untainted by the classical training against which he had rebelled in his youth. 'Nothing is more difficult for a true painter than to paint a rose, since before he can do so, he has first to forget all the roses that were ever painted,' he wrote in 1953. 'I have often asked visitors who came to see me at Vence, "Have you seen the acanthus thistles by the side of the road?" No one had seen them; they would all have recognized the leaf of an acanthus on a Corinthian capital, but the memory of the capital prevented them from seeing the thistle in nature.' Matisse, himself, had unhappy memories of drawing Corinthian capitals while studying at the École des Beaux-Arts in Paris during the 1890s.

Inside the hothouse of his villa, however, something much stranger than an acanthus thistle and less gentle

than a rose was taking root. Too frail to paint, Matisse was developing a way of making art that allowed him to work even when he was still sitting up in bed; and, over time, he became so captivated by the breathtaking results that he gave up painting altogether.

Under his direction, his assistant Lydia Delectorskaya would brush bright and generally unmixed gouaches – opaque, quick-drying, water-based paints – on to sheets of white paper. Sitting in bed or in a chair, Matisse would then cut into these colour-saturated sheets with alacrity and verve, wielding his scissors with the dexterity of a tailor cutting elaborate patterns from a bolt of cloth. Ever since he was a boy growing up among the steam-powered looms of the weavers' town of Bohain-en-Vermandois, near the Belgian border in the north of France, Matisse had always loved textiles. His new technique was in part inspired by his collection of exotic fabrics from Algeria, China, Congo, Tahiti and elsewhere, especially the gaudy floral shapes of a beloved appliqué Egyptian curtain that he owned.

Matisse was just as adept with embroiderer's scissors, which he used for small shapes, as he was with heavier tailoring shears. Generally he worked with his scissors wide open, carving the colour, rather than snipping or clipping, and only opening and closing the blades when it came to tight angles. Although he often made preparatory sketches, he never cut along lines drawn directly on to sheets of paper. 'There is nothing to resist the passage of the scissors,' one of his models, Annelies

Nelck, recalled later. 'And the little creatures extracted from their element fall from the scissors in quivering spirals, and subside like those fragile organisms the sea leaves washed up on the sand.' Once his adroit blades had freed these intricate paper shapes on to his counterpane, Matisse could arrange them into compositions by pinning them on a board.

Working in this fashion during the second half of 1943, and throughout the following year, Matisse created most of the explosive cut-paper designs for *Jazz*, a book of nearly 150 pages including twenty colour plates that was eventually published in September 1947. Although Matisse dismissed it as a 'penny plaything', *Jazz* was his first important cut-out project, heralding what would become his preferred medium in the final decade of his life. According to the American art historian Jack Flam, it is also 'the closest thing to an autobiography that Matisse has left us'.

Jazz was not the first example of Matisse's use of cut paper in one form or another in his art. In 1930, after a decade or so of painting sensuous, semi-clad young women posing as odalisques in hotel rooms in Nice, Matisse accepted a commission from the eccentric American chemist and art collector Albert Barnes to execute a mural for his foundation in Merion, Pennsylvania. Concerned by backbiting in Paris that his odalisques were too decorative and superficial – the general view was that Matisse had long since ceded his leadership of the avant-garde to his younger rival, Picasso – the painter was desperate to plunge into the

Barnes mural, which he believed could deliver him
back to the forefront of modern art. When he began
the mural, though, in a temporary studio in a garage in
Nice, he was confronted by three adjacent canvases,
each one twice his height. He quickly discovered
that planning such an immense composition, which
involved several colossal dancers, was an unruly and
difficult business. In order to help him, he asked a house
painter to provide him with large sheets of coloured
paper, corresponding to the same four hues of black,
blue, pink and pale grey that he planned to use in the
finished painting, which would be called *Dance*. As
Matisse drew and continuously altered his gigantic
figures – using a stick of charcoal attached to a long
bamboo rod that he brandished, according to one wit-
ness, like a magician's wand – pieces of coloured paper
were cut to fit the changing shapes. Once the forms of
the dancers had been finalized, the hundreds of tiny
bits of paper layered on top of one another were
removed from the canvases in order to make way
for the uppermost coat of paint. In a similar fashion,
Matisse used cut paper as a compositional aid while
working on his important *Pink Nude* of 1935. At this
point in his career, then, Matisse was using pieces of
cut and coloured paper as a means, not as an end.

In 1936, though, he made perhaps his first independ-
ent cut-out: an abstract design in red, blue, black, white
and light green, mixing straight and curving diagonal
lines with triangular shapes, for the cover of the influ-
ential French journal *Cahiers d'Art*. Gradually, the

possibilities of cut paper were imposing themselves upon Matisse's imagination. Towards the end of the Thirties, he used paper cut-outs again while planning the décor, including scenery and costumes, for a Ballets Russes de Monte Carlo production of *Rouge et noir*, with choreography by Léonide Massine and music from Dmitri Shostakovich's First Symphony. Then, in 1941, in an experiment that pointed the way towards his future endeavours, he reprised *Still Life with Shell*, an oil painting from the previous year, in cut paper. In this work, two black strings demarcate the edges of a table that supports various objects, including a coffee pot and jug, a cup and saucer, several apples, and an impressive seashell that Matisse had brought back from Tahiti in 1930. Each of the elements appears to be positioned temporarily, like a counter in an elaborate board game, as though Matisse was still tentatively trialling a new method that he suspected might prove fruitful, although he did not yet know how. He also used paper cut-outs to design covers for the magazine *Verve*, which was published by a Greek best known by his nom de plume, Tériade. In one, silhouetted black figures dance and topple against a green background decorated with stars.

It was Tériade who published *Jazz*, having first broached the idea of producing an album illustrated with colourful designs by Matisse in 1942. Tériade later recalled visiting Matisse with his assistant Angèle Lamotte in the artist's studio in Cimiez the following summer. There, as well as one of the covers for *Verve*, they saw 'two large

bright coloured plates – *The Clown* and *The Toboggan* – which were to be the first and last pages of *Jazz*. The *Jazz* cycle was born.' In *The Clown*, a circus performer wearing a white costume decorated with red flame-like shapes stands to the right of a black-and-yellow form representing a curtain. In *The Toboggan*, in between strips at the top and bottom containing explosive, angular bursts of red and yellow, a blue female figure rolls weightlessly through violet space, as though she has just fallen off a sledge travelling downhill at high speed.

The format of the book was probably finalized the next spring. Matisse's illustrations would be stencil-printed with a brush, instead of roller or spray, and would replicate exactly the colours of the Linel gouaches that he had used in his original cut-out maquettes or models. Indeed, one of the reasons why Matisse was drawn to Linel paints for his cut-outs in the first place was because they corresponded directly to commercial printers' ink colours. There would also be a text reproducing the artist's own handwriting in black and white. According to Lydia, this was composed spontaneously in 1946, after the pictures were finished. It consists of a series of gnomic reflections on Matisse's life as an artist as well as on the role and nature of art: 'Renoir once said to me: "When I have arranged a bouquet for the purpose of painting it, I always turn to the side I did not plan"'; 'An artist should never be a prisoner of himself, prisoner of a style, prisoner of a reputation, prisoner of success, etc.' Matisse wrote it

out several times until he was satisfied with the appearance of his handwriting, which, as he stated near the beginning of *Jazz*, had an important aesthetic role: 'The exceptional size of the writing seems necessary to me in order to be in a decorative relationship with the character of the colour prints.'

The loops and flourishes of his handwriting provide a lively impression of the artist's presence. This complements the personal nature of the images, which, as Matisse says towards the end of his text, 'derive from crystallizations of memories of circuses, folktales, and voyages'. Indeed, circus imagery is so common in *Jazz* that the original title for the book was 'The Circus'. Inside its pages, in addition to the clown first seen by Tériade in 1943, we find acrobats, trapeze artists, a high-wire walker, a knife-thrower, an equestrienne, a sword-swallower, a swimmer in a tank, a cowboy, a ringmaster and a white elephant balancing precariously on a ball emblazoned with a blue star. Interspersed among these circus illustrations are several more enigmatic images, such as two silhouetted female torsos, a wolf's head, a scarlet heart and – most famously of all – the mythical figure of Icarus, entirely black except for the red circle of his heart, tumbling to his death against a blue sky brightened by jagged yellow stars. 'In an earlier version Matisse had shown Icarus, his heart a red star, shooting down a blue diagonal path between black star-studded skies,' Alfred Barr wrote in his landmark study *Matisse: His Art and His Public* (1951). 'Here, in the final

version, his heart is reduced to a palpitating scarlet dot which scarcely animates his dangling limbs as he falls through deep blue infinity.'

Towards the end of *Jazz*, Matisse included three semi-abstract *Lagoon* compositions inspired by his voyage to the South Seas in 1930. The final colour plate is *The Toboggan*, one of Matisse's earliest stand-alone cutouts. The acrobatic woman at its centre anticipates by almost a decade the remarkable series of free-floating blue nudes, bathers, acrobats and monkeys that Matisse would later produce during the spectacularly productive year of 1952.

The National Art Library in London owns one of the 250 numbered copies of the 1947 folio edition of *Jazz*. Leafing through its 146 pages is a scintillating experience. In the accompanying text, Matisse refers to the 'vivid and violent tones' of the images, but this barely does justice to the barbaric colours of the twenty stencil plates, fifteen of them double page. Undimmed after more than six decades, they still throb as though emanating pulses of pure light. At the behest of his oculist, Matisse, who often worried about his weakening eyesight towards the end of his life, had to wear dark glasses as a precautionary measure while working on *Jazz*, because the incandescence of his colourful bits of paper was so intense. 'Send me a white cane,' he wrote in March 1944, after finishing nearly all of the twenty compositions for *Jazz* promised to Tériade, half joking that his work had almost turned him blind. 'For the moment I am resting completely. My eyes are

strained and my sight has gone misty. My oculist maintains that it is due to my looking at too many vivid and sometimes virulent combinations of colours that are rich to the point of saturation, and doing so with such fervent passion, since they were stuck on the wall and constantly in front of my eyes, and the part of my brain that deals with colour was constantly over-stimulated by an intoxication that is delicious but oh so dangerous.'

On a straightforward level, of course, *Jazz* expresses the joyful sense of rejuvenation and relief that Matisse felt following his reprieve from death. In its text, he compared cutting into painted paper to 'drawing with scissors'. He loved his new method because it allowed him to follow his impulses, and the results were spontaneous, like jazz music. In fact, his new paper cut-outs appeared so pleasingly impromptu and off-the-cuff that Matisse changed the title of his illustrated book to reflect the free-form, improvisational nature of their composition. 'Music was indispensable to Matisse,' Tériade said. 'Cut paper was like jazz music.' Matisse, who was a keen collector of birds, also used another metaphor to express the pleasure he derived from working with scissors and paper: 'I would say it's the graphic, linear equivalent of the sensation of flight.' He even came to prefer his new method to drawing: 'Scissors can acquire more feeling for line than pencil or charcoal,' he said later, in 1952.

Frustrated by his bedridden inability to paint, then, he had discovered a way of working that afforded him the vigour and agility he now found it impossible to

muster in front of an easel. *Jazz* also liberated him from old habits. 'What I did before this illness, before this operation,' he wrote to a friend, 'always had the feeling of too much effort; before this, I always lived with my belt tightened. What I created afterwards represents me myself: free and detached.'

His image of a tightened belt was revealing. For much of his life, Matisse was mocked for being stuffy and constrained. Unlike Picasso, who always looked like a bohemian, Matisse dressed like a businessman, often appearing in a suit. He was nicknamed 'the Professor' on account of his gold-rimmed spectacles and neat beard. In public, he could seem reserved, self-regarding, even boring. In private, he was sober, abstemious and hard-working. In 1919, while living in Nice, he described himself in a letter to his wife as 'the hermit of the prom-enade des Anglais'. Perhaps because of his reputation for stiffness, on one occasion Picasso's cronies refused to talk to him after he walked into a café in Montpar-nasse in Paris. On the other side of the Channel, in London, the Bloomsbury Set often sniggered about his slow-wittedness, characterizing him, in a memorable formulation recorded by the British art critic Clive Bell, as 'the greatest living painter, the greatest living egoist and the greatest living bore'. In a series of famous photo-graphs of Matisse drawing a model in a studio in Paris, taken by the Hungarian photographer Brassaï in 1939, the artist wears a grave expression and a white work-man's coat, like a scientist striving for a cure for cancer in

the laboratory, even though a naked woman is standing or lying just a few feet away. In Matisse's face there is not the faintest hint of pulse-quickening desire.

And yet within him, kept in check beneath the 'tightened belt' of his public persona, was a wilder, franker, more intuitive self that often emerged in his work before roaring into life during his final decade. 'I've always worked like a drunken brute trying to kick the door down,' he once said. This rowdier, more unruly side to his character went on the rampage during the Forties, and is evident throughout *Jazz*.

Moreover, the bold, bright colours and flat, graphic simplicity of *Jazz*'s plates look forward to Pop Art as well as to other artistic developments of the Fifties and Sixties. The American abstract painter Ellsworth Kelly is indebted to the visual discoveries articulated by Matisse in *Jazz*, while the rectangles of colour in *Destiny*, in which a tiny couple in white kneel before a gigantic, glowering African mask meant to represent fate, anticipate the banded geometric abstractions of Kenneth Noland and the *Protractor* series of Frank Stella. *The Heart*, presented in scarlet on a white background – like a torn ace from a pack of wonky playing cards on top of other rectangular shapes in pink and black – prefigures the imagery of the American Pop artist Jim Dine. Not for nothing did Andy Warhol say, 'I want to be Matisse.'

Yet there is another side to *Jazz*, which is not immediately obvious. As well as startling colours, Matisse

constructed its illustrations using a surprising amount
of black. In addition to the monochrome handwrit-
ing, seventeen of the twenty colour plates incorporate
black to a greater or lesser degree. This ranges from
the odd black frond of seaweed in the *Lagoon* composi-
tions, to the black of the safety-net in *The Codomas*
(the Codomas brothers were famous trapeze artists at
the beginning of the 20th century), to the use of black
silhouettes in *The Cowboy* and *Icarus*, to the black back-
grounds in *The Clown*, *Destiny* and *The Heart*, as well as
elsewhere.

In part, Matisse used black so liberally in order to
offset the brightness of the colours. In part, too, it was
a way of showing off. The aged Impressionist painter
Pierre-Auguste Renoir, whom Matisse had befriended
years earlier, and whom he quoted in the text accom-
panying *Jazz*, once told him: 'All my life I have been
saying one can't use black without making a hole in the
canvas. It's not a colour. Now you speak the language
of colour. You put on black and you make it stick.'

But, more than this, the prominence of black in *Jazz*
is an expression of the darkness of the times. In the
autumn of 1914, at the outset of the First World War,
Matisse had painted one of the starkest and most aus-
tere canvases of his career, as though he wanted to
articulate the pessimism of that moment. *French Win-
dow at Collioure* is dominated by a vast rectangle of
bottomless black that represents an impenetrable, noc-
turnal view beyond an aperture bounded by columns
of colour: blue on one side, grey and turquoise on the

other. Three decades later, while working amid another global conflict, the Second World War, he returned to this compositional device in the left-hand panel of *The Heart* in *Jazz*.

Indeed, the more you examine *Jazz*, the more apparent its allusions to warfare become. The poet Louis Aragon, who interviewed Matisse in the Forties, was the first person to spot this. In 1971, he recalled seeing the initial version of *The Fall of Icarus*: 'From Matisse's own confidential comments we gather that the yellow splashes, suns or stars according to mythological interpretation, stood for bursting shells in 1943.' This insight provides the key that unlocks the dark secrets of *Jazz*. If the spiky yellow stars of *Icarus* represent artillery explosions, then the serrated forms adorning the top and bottom of *The Toboggan* must be similarly threatening. In this light, the somersaulting fall of the tobogganist evokes the death roll of a soldier who has just been hit by gunfire. For me, Matisse's blue figure even bears a marked similarity to the fatally wounded falling soldier in Robert Capa's famous photograph taken during the Spanish Civil War, in 1936. 'And now, my dear Pierre, what do you think of the collective madness that is ravaging both the Old World and the new one?' Matisse wrote to his son in the wake of his operations in 1941. 'Do you feel, as I do, that there is something foredoomed about it, and that the whole world is bent on destruction?' This bleak fatalism is surely the message of *Destiny*, while destruction haunts a number of the other plates. The red splashes of the

costume in *The Clown* could be the fresh wounds of a corpse recently lacerated by shellfire. *The Sword-Swallower* and *The Knife-Thrower*, whose sleek violet form is a visual pun that replicates the shape of an African throwing knife, openly evoke danger and violence. *The Nightmare of the White Elephant* is just that – a nightmare – as the white form of the poor performing beast is assailed and mangled by blade-like red welts, representing its suffering as its keeper cracks his whip.

Aside from sparse supplies and the odd air raid, the war could seem far away in the peaceful garden at Le Rêve. But in the spring of 1944, while he was still working on the illustrations to *Jazz*, Matisse received news that the Gestapo had arrested his estranged wife and his daughter, who were both active in the Resistance. 'I've just had the worst shock of my life,' Matisse wrote to his friend Charles Camoin. For three months, Matisse heard nothing about their whereabouts. Eventually he discovered that Amélie was serving a six-month sentence in a large prison south of Paris. 'I dare not think about Marguerite, of whose fate nothing is known,' he told Camoin. Matisse, who was not involved with the Resistance, heard from Marguerite only after the Allies' liberation of Paris, when he learned that she had been brutally tortured in captivity. As Hilary Spurling reveals in the second volume of her masterful biography of Matisse, Gestapo agents suspended Marguerite by her wrists, dipped her repeatedly in a freezing bath, and beat her with a steel flail and a rawhide whip until she was so demoralized that she

attempted suicide by slitting her wrists with a shard of glass. In January 1945, Marguerite arrived at Le Rêve, where she described her annihilating ordeal in detail to her father for four hours every afternoon over fifteen days. 'I was as if hypnotized – really hypnotized – by the memories that came flooding back within her,' Matisse wrote to Pierre the following month. 'After she left, I was a wreck for several days.'

These events exacerbated Matisse's insomnia and general mood of distress. Surely there is no question that he sublimated his vicious anxiety in *Jazz*, transforming it into something potent and poetic. 'My drawings and my canvases are pieces of myself,' he said during an interview with the French poet and essayist André Verdet in 1952. 'Their totality constitutes Henri Matisse.' His remark is especially pertinent to *Jazz*, which was explicitly personal. After all, Matisse often compared his own work to the performances of jugglers, tightrope walkers and acrobats, who all appear within *Jazz*'s pages, arguably as proxies for the artist. Yet, while he said that its images were 'crystallizations' of his 'memories', the book's pictures do not simply animate happy recollections of the itinerant tumblers and Gypsy fortune-tellers who had passed through Bohain-en-Vermandois, where Matisse grew up. His private fears during the war are writ large within *Jazz*, too. The growling wolf alludes to the Gestapo. *Pierrot's Funeral* – in which jaunty autumn leaves surround a horse-drawn cortège bearing the coffin of a white-faced circus clown with a star-shaped heart coloured a

passionate red – is a mock version of the funeral that
Matisse himself narrowly escaped in 1941. In light of
what happened in prison to Marguerite, the red weals
of the white elephant have an extra grisly significance.
Even the starry explosions of *Icarus* and *The Toboggan*
can be understood as expressions of Matisse's pain: in
November 1943, in a letter to Marguerite, he compared
himself to 'someone hit by a shell blast . . . with the
wall of his stomach blown away'. This undertow of
menace and melancholy is reinforced by the text,
which refers to the 'violence' of the colour plates, and
begins with an image of bodily mutilation: 'He who
wants to devote himself to painting must begin by cut-
ting out his tongue.' For me, the juxtaposition of the
overt brightness of the illustrations and the darkness of
some aspects of their subject matter is what makes *Jazz*
such a powerful and moving work of art.

Two years before he began the book, Matisse had
embarked upon a more explicit work of autobiography
while he was still recuperating in Lyon. At the sugges-
tion of the Swiss publisher Albert Skira, he started
meeting up with the art critic Pierre Courthion, begin-
ning in April 1941. Relating anecdotes and drawing
upon memories of his long career, Matisse spoke inti-
mately to Courthion, who recorded their conversations
before editing them into a revealing manuscript con-
sisting of nine separate encounters. 'The book will
mark an important moment in my life: the sort of
physical resurrection that I feel, which really is a resur-
rection,' Matisse said in the foreword. Skira and

Courthion hoped to publish this series of conversations under the title 'Bavardages', or 'Chats'. While preparing the final text, though, Matisse got cold feet. He became concerned that publishing the conversations would be a mistake, perhaps because they were too gossipy and informal, or insufficiently insightful about his motivations as an artist. Whatever the reason, after much reflection, and having consulted friends, Matisse exercised a clause in the contract that he had signed with Skira and withdrew his approval for the book, which remained unpublished until 2013.

This episode is another important context for the origins of *Jazz*, which is a more elliptical and mysterious version of the 'Bavardages' project. In many ways, *Jazz* dramatizes Matisse's recent tribulations, transforming them into something embellished and profound – just as, in the words of Ariel in Shakespeare's *The Tempest*, Ferdinand's father, lying on the seabed five fathoms beneath the surface, suffers a 'seachange' into something 'rich and strange', with coral for bones and pearls in place of eyes. Take another look at Matisse's sword-swallower: with his unusual, leaflike eye, he appears to be metamorphosing into some sort of timeless figure of myth. In *Jazz*, Matisse proved to himself that a simple, childlike medium – scraps of coloured paper cut and pasted alongside one another – could create a rich effect, with personal as well as poetic resonance. Forty years earlier, when he had painted with pigments squeezed directly from the tube, his aggressive, clashing colours had signalled his first

revolutionary period, as a Fauve. Now, the jangling ferocity of *Jazz*'s 'vivid and violent tones' ushered in the final wild transformation of Matisse's art.

There is, however, an extraordinary postscript to the story of *Jazz*: Matisse considered it a 'failure'. Following its publication, in a letter to his old friend André Rouveyre, written in December 1947, he expressed his disappointment that the images in the book had, in his view, 'the character of a puzzle'. This was in contrast to the 'sympathetic' attitude he felt towards his cut-outs when he saw them on the studio wall. 'I think that what absolutely ruins them is the transposition, which removes their sensitivity,' he explained. And yet, he told Rouveyre, he did not feel discouraged. In fact, he was 'busy this afternoon making new combinations of colours with the paper cut-out system'. 'I know that these things must stay as they are, originals – very simply, gouaches,' he wrote.

According to Lydia, working on *Jazz* gave Matisse the idea that 'you could draw expression from assembled gouached papers.' As a result, before the book was even published, he was already experimenting between 1944 and early 1946 with other cut-out compositions that were not meant for translation into any other medium. Several of these were simple, geometric configurations: circles, squares and triangles on monochrome backgrounds. But there were also a few solitary palm fronds, as well as a propeller, a flower with four petals, a daisy and an Ace of Clubs. Matisse spent a lot of time scrutinizing his latest creations. 'Finally,' Lydia recalled, 'he

made a cut-out, *The Lyre* [1946], a small thing, blue on white, and said, "It's my first cut-out", that is to say, a well-thought-out work, which he succeeded in investing with feeling. That was the start.' With *The Lyre*, in which the stringed instrument of the title, cut out of a sheet of blue paper, resembles a plume of water, Matisse's second life as an artist had begun.

3
Oceania

Visitors to Vence often remarked upon the prowess and ingenuity with which Matisse used scissors. One of them was a young artist called Françoise Gilot, who was living with Picasso in the south of France. In her book *Life with Picasso*, she recalls arriving at Matisse's villa to find him working in bed, looking 'very benevolent, almost like a Buddha. He was cutting out forms, with a large pair of scissors, from very handsome papers that had been painted with gouache according to his directions.' In 2009, I met Gilot in New York and asked her what she recalled about this encounter. 'I couldn't believe that his scissors were so large,' she told me. 'With great skill, he could create whatever shape he wanted. He did it very fast, with dynamism, and if something did not please him, then he would re-cut it. He just went about it in a very spontaneous manner.' Picasso and Gilot were so dazzled by the virtuosity of Matisse's scissor-work that they once brought a magician to his bedside to honour the ability of the older artist to conjure wondrous forms out of nothing.

Photographs of the interior of Le Rêve document this crucial period when Matisse was becoming more

and more excited about the possibilities of paper cut-outs. In one, an entire wall is decorated with his inventions: sinuous, luscious forms that loop and sway, evoking leaves, floating clumps of seaweed, submarine sponges, algae and coral. There is a palpable sense of rampant growth: Matisse's creativity is taking over, like a vine creeping inexorably across masonry. The artist controlled the arrangement of these cut-outs with the help of Lydia, who would pin and paste the pieces of paper to their backgrounds and then to the wall. At this stage, the cut-outs were still relatively small, because Matisse made many of them in bed. Once he had completed *Jazz*, however, this changed.

Not long after Gilot and Picasso visited Vence for the first time in the spring of 1946, Matisse decided to spend the summer in Paris, in his apartment at No. 132, boulevard du Montparnasse. While he was there, his habitual insomnia became particularly acute. 'I've never slept more than five hours,' he said in 1941, but now he was only managing three or four hours a night. In general, when he couldn't sleep, he passed the time by working: later, in Nice, he even drew on his bedroom ceiling while lying on his back, using a piece of charcoal attached to the end of a bamboo pole. That summer in Paris, though, perhaps as early as July, he decided not to draw, but to make cut-outs instead. Inspired by a book of Tahitian photographs that he kept beside his bed, he picked up a block of humdrum white writing paper and started to cut shapes that reminded him of his trip to the South Seas in 1930.

The first image was a simplified silhouette of a swallow. Matisse thought it looked so beautiful that he asked his nurse, who kept him company at night, to pin it to the pale brown wall of his bedroom. This had the added benefit of covering up a stain that had disturbed him. Next, he produced a fish. 'Over the following weeks other shapes were cut out and put up on the same wall,' Lydia recalled in a note written for the Matisse Museum in the artist's birthplace of Le Cateau-Cambrésis in 1997. 'Little by little all this ended up becoming an entire composition that decorated the whole wall-panel.'

Photographs of Matisse's apartment taken that summer reveal the different stages of this composition. To begin with, his white cut-outs, including a turtle that was later discarded, shared his bedroom wall with linocuts and drawings in charcoal and brush and ink, as well as a calendar and a handful of trophy targets that Matisse had won at a nearby shooting booth, which he visited with Lydia for fun. (It appears that Matisse was quite the marksman: in each target, rifle shots graze the edge of the bull's-eye.) Eventually, however, Matisse's ghostly white forms took over the whole wall, to the exclusion of anything else. 'The composition then was given a provisional name: "The Fairy", based on the central pattern,' Lydia recalled.

This pattern is surely one of the most delicate and magical shapes that Matisse ever cut: a shivering will-o'-the-wisp, head bowed, arms curling outwards

in expectation of an embrace, hovering in mid-air, as evanescent as smoke. Matisse was so pleased with his new ensemble, which he was soon calling 'The Water Fairy', that he began a pendant panel on an adjacent wall, on the other side of a door opening on to a corridor. Like its predecessor, this was also spurred by memories of Tahiti, but this time Matisse cut out starfish, sea slugs, manta rays and sharks as well as birds. The second composition was initially known as 'The Jellyfish', on account of the forms resembling jellyfish or seaweed that appeared in it so prominently.

In 1944, while working on *Jazz*, Matisse had already illustrated his memories of swimming through lagoons during his trip to Polynesia. 'Lagoons: Aren't you one of the seven wonders of the Paradise of painters?' he wrote in the accompanying text. By 1946, his rhapsodic recollections could no longer be confined within the covers of a book. In the dead of night, unable to sleep, he quietly gave form to his vivid memories, which emanated from his mind like a miasma or fine mist, seeping into walls, creeping over dado rails, nudging against cornices, and even spreading into awkward spaces above bookcases, chests and doors. At first, Matisse did not know what to do with the decorations in his Parisian bedroom. 'I am cutting out all these elements and putting them up on the walls temporarily,' he told the photographer Brassaï, who visited the apartment that summer. 'I don't know yet what I'll come up with. Perhaps panels, perhaps wall-hangings.'

Eventually, thanks to Matisse's collaboration with a charming and persistent young Czech émigré textile designer called Zika Ascher, the twin compositions became two beautiful works of art screen-printed on linen known as *Oceania, the Sky* and *Oceania, the Sea*. Each would be nearly 12½ feet wide.

Throughout his life, art had offered Matisse a form of escape. Since *The Open Door, Brittany*, his painting of 1896, one of his most famous motifs had been the open door or window, providing a tantalizing glimpse of somewhere more exciting. This is what we find in *Studio under the Eaves* (1903), where the sunlit view through the window offsets the claustrophobic drabness of the bare, brown room in the foreground. We encounter something similar in *The Open Window* – painted in Collioure in the first Fauvist summer of 1905 – in which blue boats with orange masts bob and tip in a sea seething with otherworldly mauves, violets and pinks. In paintings such as these, Matisse was enacting the general trajectory of his life – as he moved away from the prim, bourgeois world of repressive conformity in grey-skied northern France, where he grew up the son of a seed merchant and trained as a lawyer's clerk, and 'plunged headlong' towards the paradise of light, colour, instinct and freedom that he encountered in small fishing villages along the coast of the Mediterranean, and in the landscapes of North Africa. 'It was a tremendous attraction, a sort of Paradise Found in which I was completely free, alone, at peace,' he once said about his

conversion to painting, which saved him from a mediocre career in law.

Four decades on from that breakthrough summer in Collioure, Matisse no longer needed to visualize a window at all. Like a fairground magician using sleight of hand, with a few deft strokes of his scissors he could transform an ordinary bedroom wall into a portal transporting the viewer to another time and place. In the work taking shape on the walls of his Parisian apartment in 1946, that location was Tahiti, where Matisse had disembarked from the Union Steamship Company vessel, a beaten-up mail-boat which he had boarded in San Francisco, upon its arrival in the island's capital Papeete on 29 March 1930.

Travel was an old trick that Matisse used to refresh his art whenever he felt stymied. His two trips to Morocco between 1912 and 1913, for instance, had proved especially fruitful. By 1930, as we have seen, he was concerned that his heroic years as a painter were behind him. 'In front of the canvas, I have no ideas whatever,' he wrote with despair to Marguerite in November 1929. In order to dispel this crisis of confidence, he decided to travel to Tahiti. 'Since the main goal of my work is clarity of light, I wondered, "What can it be like on the other side of the hemisphere?"' he told Pierre Courthion in 1941. Although he later denied it, it is also likely that he was deliberately following in the footsteps of the Post-Impressionist painter Paul Gauguin, who had lived and worked in French Polynesia.

In 1899, Matisse had acquired a painting of a boy's head by Gauguin, while his discovery in 1905 of Gauguin's primitive wooden carvings had a major impact upon the development of his art. 'You can't live in a household that is too well kept, a house kept by country aunts,' Matisse told his friend Tériade in 1929, shortly before his Tahitian voyage. 'You have to head for the jungle to find simpler ways of doing things that don't stifle the spirit.'

Matisse's first impressions of Tahiti were hardly earth-shattering. He was far more impressed by the 'crystalline' light of New York, which he had visited en route to the South Seas: 'New York seemed to me like a gold nugget,' he recalled later. 'On the Fifth Avenue sidewalk, I was truly electrified.' In Papeete, by contrast, he was bored. 'I remember that first of all, on my arrival, it was disappointing,' he told Verdet in 1952. Although he was well looked after by a Tahitian woman called Pauline Schyle, the former lover of a French novelist friend who had been a colonial administrator on the island in the early Twenties, Matisse found that there wasn't a tremendous amount to do. Once he was installed in a room with an ocean view in the Hôtel Stuart, a modern concrete block overlooking the waterfront in the middle of Papeete, he whiled away his time with morning massages for his arthritic legs and afternoon visits to the covered central market, where he revelled in the abundant splendour of its fresh fish: 'lumpfish, huge sea-bream, orangey red mullets, purply crimson mullets, Prussian blue and emerald green fish

streaked with white ... extraordinary tones virtually impossible to describe'. He also enjoyed sketching breadfruit trees and other unfamiliar plants in the gardens of the Archbishop's Palace. On several occasions he accompanied Pauline and her husband in their Buick on excursions around the island. He spent some time with the German film director Friedrich Wilhelm Murnau, who was there shooting his new movie *Tabu: A Story of the South Seas* (1931), which Matisse, who enjoyed going to the cinema, would see three times following its release in France. Otherwise, though, he encouraged few social engagements, preferring to spend his evenings alone in his hotel room, where he read little, and tried to sleep. In one sketch, we see his solitary, somewhat comical and cartoon-like figure, apparently sporting the pith helmet that he wore for much of the trip, reflected in an oval mirror on the hotel wall.

He had more fun touring the coral atolls of Apataki and Fakarava in the Tuamotu Archipelago, where he went for rapturous swims in lagoons with water the colour of diamonds, emeralds and sapphires. 'The fish come all around you, just like flies in France – they're not frightened,' he said. Eventually he set sail from Tahiti for France on 15 June, arriving in Marseille at the end of July. Aside from his drawings of Polynesian vegetation, he returned with nothing but a few sketches of Pauline, with her thick hair massing upon her shoulders, other Tahitian women wearing floral headdresses, and fishermen beside their boats. In addition to this

group of around forty drawings, he had taken a few uninspiring black-and-white photographs of the islanders, his hotel terrace, the port of Papeete, birds plunging into the sea to fish, coconuts scattered across beaches and windswept palm trees. In terms of productivity, it wasn't much. As Matisse put it to Brassaï in 1946: 'I came back from the islands absolutely empty-handed.' Perhaps Picasso got wind of Matisse's disappointment. This would help to explain why he once mischievously said: 'It seems to me it must be very galling to travel to the other side of the world, as Matisse did in Gauguin's footsteps, only to discover that, after all, the light over there and the essential elements of the landscape that attract the painter's eye are little different to those he could find on the banks of the Marne or the plain of the Ampurdán.'

Matisse sometimes felt that Picasso visited him after the Second World War only so that he could study his new paper cut-outs, which would then 'ferment in his [Picasso's] mind to his advantage'. So it was with Tahiti for Matisse. While he was there, he had become fascinated by Polynesian *tapa*, a type of handmade, beaten barkcloth often decorated with geometric designs, and *tifaifai*, appliqué bedspreads, stitched together using plain fabrics cut into simple, plant-like shapes. There is an obvious relationship between these traditional Tahitian fabrics and the look and technique of Matisse's later cut-outs. Moreover, as the years passed, his memory of the South Pacific light, which he often compared to gazing deep into a gigantic golden goblet, grew ever brighter. While

illustrating *Jazz*, Matisse felt compelled to articulate his strong feelings about the shimmering colours of the tropics in the three *Lagoon* compositions towards the end of the book. In the two panels of *Oceania*, this passion became consuming. 'The memories of my voyage to Tahiti have only now returned to me, 15 years later, in the form of obsessive images: madrepores, corals, birds, jellyfish, sponges,' he told Brassaï. 'It's curious, isn't it, that all these enchantments of the sky and sea hardly inspired me right off.'

As Matisse was putting the finishing touches to the large designs in his bedroom, Zika Ascher visited him for the second time that year. A few months earlier, Ascher, who hoped to persuade modern artists to design silk scarves that he could then produce and sell, had cold-called Matisse using a public telephone in a Parisian café. His silver tongue won him an invitation to Matisse's boulevard du Montparnasse apartment, where Ascher inquired whether the artist would consider taking on a decorative commission for his London firm. Matisse did not dismiss the proposition out of hand, but instead suggested that Ascher should visit him again when he was next in Paris. When Ascher returned, he found Matisse sitting on his bed, with paper and scissors in hand, directing his assistants. The artist said that, if he liked, Ascher could reproduce the designs that were still pinned to the walls in his bedroom. Ascher's enterprising approach was rewarded with good luck: he had met Matisse at an opportune moment, when the artist was mulling over what to do

with his latest creations. The two men agreed to work together and signed a contract on 1 October 1946.

Ascher may have been thrilled, but now he had to crack the problem of how to reproduce Matisse's ephemeral scraps of paper, which were held in place with nothing more secure than pins. He decided to use silk-screen printing. Matisse was happy to give this a go, but he was adamant that the white in the finished silkscreen had to be 'absolute', and that its background should replicate precisely the colour and texture of the pale beige wallpaper that lined his bedroom, since this reminded him of the sand on the seabed and the golden light of Tahiti. It took Ascher two years to find a white that was suitable, but he was unable to come up with anything satisfactory for the background. In the end, Matisse sent him samples of stiff linen stocked by a fabric supplier in the Breton town of Uzel. Finally, in 1948, after much back-and-forth between Matisse and Ascher, the Belfast Silk and Rayon Company printed the two panels, each in an edition of thirty identical examples, which were then sent to Nice for the artist to check, number and sign. The original cut-outs, which had been transferred to London, were returned to Matisse, who never remounted them.

While working on the *Oceania* panels, Matisse agreed to design a headscarf, which Ascher produced in a limited edition of 275. He also created two related cut-paper murals, *Polynesia, the Sky*, and *Polynesia, the Sea*, which became the basis for tapestries. In these woven works, the white silhouettes of birds, starfish, coral,

seaweed, and other marine creatures and plants appear within an undulating border against a chequerboard background alternating dark blue and turquoise rectangles. To create the maquettes for these tapestries, Matisse used tacky blue wrapping paper – the only material that Lydia could find after rummaging through most of the stationery shops in Paris – declaring that with 'ugly colours' he would make something 'beautiful'.

The *Oceania* panels were Matisse's first large-scale cut-outs. As such, they represent a milestone in the route his art would take in his final decade: two years before his death, he would begin *Memory of Oceania*, another massive cut-out inspired by his trip to Tahiti. It is true that several of the shapes in the *Oceania* hangings, as well as the *Lagoon* plates of *Jazz*, owe something to the biomorphic forms of the Spanish painter Joan Miró and the French artist Jean Arp, and, beyond them, to the abstracted shapes of Art Nouveau. But they also embody a fresh approach to making a picture. Unlike some of Matisse's other cut-outs, the *Oceania* panels do not conform to the rules of easel painting, in which objects are conventionally situated within a believable space. With *Oceania, the Sky* and *Oceania, the Sea*, the forms hover and float, untethered by anything apart from the wavy border, and their dancing, rhythmical relationships with one another. Somehow, despite appearing to swoop and dart, Matisse's white birds and sea creatures are balanced in a gentle equilibrium – like particles suspended evenly in a liquid. As a result, the hangings have a decorative, 'all-over' quality, which

can be compared with similar preoccupations of American painters such as Cy Twombly and Jackson Pollock, who overlapped with Matisse, and who both avoided letting their pictures become dominated by a single focal point of interest. This approach is particularly appropriate for the subject matter of the *Oceania* panels, since it mimics the experience of swimming through crystalline South Sea lagoons, floating weightlessly while borne aloft by salt water, gazing intermittently down at the sea floor and up towards the sky. We become like the tumbling female figure in *The Toboggan* in *Jazz*: unsure which direction is up, and which is down. Even the creatures associated with the different zones of sky and sea merge into one another: there are fish in the *Sky* panel, and birds in the *Sea*. The forms themselves have a wonderfully soft, floppy, unguent quality: several birds in *Oceania, the Sky*, for instance, look like molluscs propelling themselves through water, past seaweed, coral, sea serpents and fish. This shape-shifting quality creates an enchanting atmosphere.

Moreover, there is something brilliant about the contrast between the splendid spectacle of the overall effect, and the poverty of the means by which that effect is generated. After all, the starting point of these panels was nothing more than blank writing paper cut up and pinned to a plain wall in the middle of the night. The vibrant colours of *Jazz* have disappeared, replaced by ethereal white and nondescript beige. Compare the luminous yellow stars in *Icarus*

with the two *Oceania* hangings: in the latter, it takes quite a leap of imagination to follow Matisse in linking the bland wallpaper of his Parisian apartment with the golden sand and light of Tahiti. But this, for me, is what these works are about: the power of the imagination to trump deprivation. Matisse found himself obsessively thinking about the paradises of Polynesia in the aftermath of war. In other words, he embarked upon an imaginative voyage from the confines of his bed during a time of austerity. Only a few years earlier, he was complaining that he couldn't easily obtain lemons for a still life. Late at night in 1946, imprisoned within his own wakeful mind, he once again had to overcome a paucity of resources in order to make art. The resulting collision between the abundance of the subject matter (limitless avian and marine life) and the restraint of its expression (uniform white against pale fawn) surely articulates the exhausted atmosphere of post-war Paris, as well as the fugitive nature of memory. In *Oceania, the Sky*, that 'Paradise of painters', as he described his lagoons in *Jazz*, has become a blanched ghost – indeed, the original title of 'The Fairy' suggests the insubstantial nature of the final work. We are looking at a memory. We are confronted with paradise lost.

And yet, in spite of physical frailty and debilitating insomnia, Matisse still managed to conjure a make-believe realm that could impart something of the joy and freedom he had experienced while swimming off coral atolls in the Pacific Ocean. Despite the recent

ravages of the war, here was a faint but glimmering vision of a better place – a place characterized by sumptuousness, tranquillity and sensual pleasure, in the words of the title *Luxe, calme et volupté*, a famous oil painting by Matisse first exhibited in 1905. With the *Oceania* hangings, Matisse had proved that paper cutouts could create a satisfactory effect on a big scale. He was now ready for the most ambitious project of his life: the Chapel of the Rosary at Vence.

4
Vence

Towards the end of his life, Matisse was certain about one thing: the Chapel of the Rosary that he designed for the Dominican nuns at Vence was his masterpiece. In his introduction to a picture book about the chapel, published in 1951, he called it 'the culmination of a lifetime of work'. When I first read this, it struck me as an odd thing to say, not only for a man who had devoted most of his career to painting, but also for someone who considered himself an atheist. Why was he so delighted with this structure? For me, the answer to this question became apparent when I visited the chapel for the first time. Its simplicity moved me to tears. As Nicholas Serota, the Director of the Tate, put it to me: 'Anyone walking into that space who doesn't feel great emotion is incapable of feeling. It has to be one of the great works made anywhere at any time. Sistine Ceiling, Vence Chapel: I wouldn't want to choose between the two.'

Built on a terrace with a panoramic view south towards the old town of Vence, and tucked against a hillside beneath route de Saint-Jeannet, the Chapel of the Rosary is a few hundred feet down the road from

Henri Matisse

Le Rêve, the villa that Matisse rented during the For-
ties. In the artist's lifetime, all that separated his villa
from the site of the chapel, aside from the road, was a
field of wild grass. The chapel was consecrated on
25 June 1951, although Matisse was forbidden from
attending the ceremony because he was too frail, so he
sent his son Pierre to represent him instead.

If Matisse's energy was depleted by 1951, who could
blame him? Designing, refining and realizing the chapel
had preoccupied him for a long time. 'This work took
four years of intensive labour, to the exclusion of all
else,' he wrote to Monsignor Rémond, the Bishop of
Nice. 'In spite of its imperfections, I regard it as my
masterpiece.' Since his initial conversation about the
possibility of decorating a chapel towards the end of
1947, Matisse was resolute that, if he took on the project,
every detail had to be just so. In the end, he designed not
only the stained-glass windows and the three major cer-
amic murals of the chapel's interior, but also the exterior
spire, the wavy, blue-and-white pattern on the roof, the
gilded-bronze crucifix and candlesticks on the altar, the
tabernacle, the wooden confessional door, the holy-
water stoups beside each of the three entrances to the
building, and the blazing patterns adorning the priest's
chasubles. He even installed a pond in the garden
outside, so that visitors would encounter goldfish –
something of a signature motif for Matisse, who had
painted them repeatedly in a number of important paint-
ings over the years, such as *Moroccan Café* (1913) and
Goldfish and Palette (1914). Creating the Chapel of the

Rosary, then, demanded the full application of Matisse's various skills as a painter, sculptor, draughtsman, ceramicist, colourist and costume-designer. It was the most substantial undertaking he had attempted since the Barnes mural in the early Thirties, which had prepared him for working on a large scale while considering the surrounding architecture.

Upon entering the chapel, visitors discover an L-shaped space, nearly 20 feet across in the nave and more than 49 feet long, with whitewashed walls and ceiling, and a pale, subtly mottled marble floor. At the far end is a rough stone altar, consisting of three semicircular slabs and a cylinder, like an architectural model for a Brutalist building. Unconventionally, this is angled along a diagonal, so that the officiating priest faces both the congregation and the pews reserved for the Dominican nuns. A row of slender, floor-to-ceiling stained-glass windows runs along the southern wall of the nave. Using a simple colour scheme of transparent ultramarine blue and bottle green, as well as opaque lemon yellow, these narrow windows contain a pattern of elongated, leaf-like forms arranged so that they appear to grow out of the intervening sections of wall, which in turn become like trunks or stems. Opposite these windows, a black mural painted directly on to a large panel of white ceramic tiles presents a simplified vision of the Virgin and Child, viewed from the front in the manner of a Byzantine icon, and surrounded by shapely flowers rendered with speed and spontaneity, as a child might sketch a fluffy cloud.

A similar juxtaposition occurs along the west–east axis of the chapel, as the splendid double-arched window behind the altar, known as the *Tree of Life*, faces the imposing, graffiti-like *Way of the Cross* mural at the other end. Although this ceramic panel is 13 feet in length and 6½ feet high, visitors do not usually notice it upon entering the chapel until they turn around. Mapped out by Matisse using a stick of charcoal attached to the end of a bamboo pole 'in a single spurt between 10 o'clock and noon' one April morning in 1949, and presenting the fourteen traditional 'stations' commemorating the dramatic events of the Passion of Christ, as Jesus carries the cross to his crucifixion, it is a much more complex and confusing composition than the mural of the Virgin and Child. It is also a rare example in Matisse's art of the explicit treatment of suffering and pain, and it contains the only face in the chapel: Christ's plaintive features can be made out on the Veil of Saint Veronica.

A third large ceramic mural featuring Saint Dominic, the founder of the Dominican order, occupies a northern wall near the altar. Clutching the Gospels with a spookily large hand with elongated, flame-like fingers, he wears a long, hooded cloak reminiscent of traditional Arab *djellabas*, which Matisse had seen in Morocco nearly four decades earlier.

The opposition between the colours irradiating the stained-glass windows and the monochrome murals animates the chapel. Matisse compared the contrasting effect to the relationship between the flowing black

lines of his handwriting and the bright colour plates in *Jazz*. 'I can tell you in confidence that it's from the book *Jazz*, from my paper cut-outs, that later my stained-glass windows were born,' he told André Verdet in 1952. Just as he had with the illustrations for *Jazz*, so Matisse used paper cut-outs to design the models for the chapel's stained glass. The final cut-paper maquette for the *Tree of Life* window, for instance, is now in the collection of the Vatican Museums.

Matisse's involvement with the chapel grew out of his friendship with his former nurse and model Monique Bourgeois, who had taken the trolley bus from Nice up to his apartment in Cimiez for the first time in September 1942, when she was twenty-one years old. 'M. Matisse was sometimes very cheerful, teasing and mocking me, but my playful nature easily adapted to this,' she later recalled. 'We were soon friends.' In February 1944, perhaps surprisingly, given her coquettish nature, Monique entered a community of Dominican nuns in south-west France, before becoming a novice and taking the name Sister Jacques-Marie later that year. As a teenager, she had suffered from lung trouble. In 1945, when her health languished again, she ended up in Le Foyer Lacordaire, a convalescent home near Le Rêve in Vence. Following her recovery, she joined Le Foyer Lacordaire as a nursing sister, and began visiting Matisse, with whom, in the words of the artist, she once again enjoyed a flirtatious relationship. 'I should like to write "fleurtation", because it's rather as if we were throwing flowers at each other's faces, rose petals,' he

wrote fondly to his friend André Rouveyre in April 1947.

Later that year, Sister Jacques-Marie told Matisse that the nuns, who were using an old garage as a place of temporary worship, wanted to build a chapel at the nursing home. With this in mind, she had painted a watercolour sketch proposing a stained-glass window depicting the Assumption of the Virgin. When she showed this to Matisse, his curiosity was piqued. He discussed her sketch with Brother Louis-Bertrand Rayssiguier, a 27-year-old novice friar with an interest in architecture who was convalescing following pleurisy at Le Foyer Lacordaire. By the end of their first meeting at Le Rêve, on 4 December 1947, the pair had already concocted ambitious plans to design an entire chapel. Five days later, Brother Rayssiguier returned with a scale plan. Within two months, Matisse was orchestrating his vision using a wooden working model specially constructed for him by Sister Jacques-Marie. 'This is not a work that I chose, but rather a work for which I was chosen by fate,' he wrote later.

Inevitably, Matisse had to overcome resistance within the Roman Catholic Church. In Paris he met an ascetic Dominican friar called Father Marie-Alain Couturier, an enlightened modernizer within the world of religious art, who was rumoured to order his white robes from Balenciaga. Father Couturier secured the approval required to build the chapel. In return, Matisse asked him to model for Saint Dominic.

By November 1948, Matisse had decided upon the

layout of the murals and windows. To make them, though, he was going to need more space than the dark, boxy rooms of Le Rêve could provide. Early the following year, therefore, a few days after his seventy-ninth birthday, he moved back to his apartment in the Hôtel Régina in Cimiez, where his spacious, high-ceilinged studio roughly corresponded to the dimensions of the chapel's interior. Here, in what Matisse called 'the factory', he could work on large charcoal studies for the murals and life-sized maquettes for the windows.

His first design for the flank windows running along the southern façade of the nave, created in the summer of 1948 while he was still living in Vence, had been a geometric composition involving lots of swarming, zigzagging little squares of red, yellow and blue, representing a field of flowers. Across this background swooped two lines of black-and-white bees, alluding to the monochrome headdresses of the Dominican nuns, and drawing upon an age-old metaphor equating beehives with orderly communities. For the west apse window, inspired by a biblical passage about the divine re-creation of the city of Jerusalem that Brother Rayssiguier had read to him, Matisse created a cut-out known as *Celestial Jerusalem*, a rhythmic grid of irregular rectangles and polygons, with lots of reds, oranges and yellows, as well as accents of blue, green and mauve.

By 1949, Matisse had rejected this in favour of a second maquette, the *Pale Blue Window*, in which swaying, seaweed-like or leaf-like forms – reminiscent

of similar shapes associated with Tahiti in the *Lagoon* compositions of *Jazz* as well as the *Oceania* wall-hangings – ascended towards heaven, against a background of multicoloured rectangles. Upon discovering, though, that he had not factored in the lead braces required to make the windows – a modest crisis recalling the debacle of the Barnes mural, when, having worked for a year on his gigantic dancers, he found out in early 1932 that his canvases were the wrong dimensions, and so was forced to start again – Matisse set about creating a third and final maquette for the chapel's apse window. Called the *Tree of Life*, it was inspired, according to Sister Jacques-Marie, by 'a succulent plant mentioned in the Apocalypse'. Now, against a green background, Matisse's Tahitian plant-forms became yellow cactus flowers erupting against tapering blue ovals representing the fleshy, spine-covered stalks of prickly pears commonly found in Vence. For Sister Jacques-Marie, Matisse's cactus had symbolic properties. Like the Tree of Life mentioned in the Apocalypse, which, she said, 'lives and flowers in the dry desert and bears fruit there', it offered an analogy for the triumph of everlasting life over death.

Matisse presented this design as though it were a curtain or a tapestry, with a curving top edge that droops down from the points where it is 'attached' to the wall – a nod, perhaps, to the success of the *Oceania* and *Polynesia* wall-hangings. Matisse was aware that the cactuses of Vence produced red flowers as well as yellow, but by this stage he had decided to eliminate red

almost entirely from the chapel, probably because the colour was too violent and therefore risked disrupting the effect of serenity that he hoped to achieve. He also wanted to reduce his palette, because he felt that 'simple colours can act upon the inner feelings with more force, the simpler they are. A blue, for example, accompanied by the brilliance of its complementaries, acts upon the feelings like a sharp blow on a gong.'

Accordingly, the flank windows in the nave also changed: Matisse replaced the busy complexity of *The Bees* – which eventually became a stained-glass window in the primary school of his birthplace, Le Cateau-Cambrésis – with pared-down leaves of blue and yellow against green. These recall a prominent column of leaves running up the left-hand edge of *Bathers by a River*, a forbidding, monumental canvas inspired by Cubism that Matisse had completed more than three decades earlier, in the autumn of 1916. But they also appear to have been inspired by a type of aloe plant common to the area – a large specimen, for instance, grows in the gardens of Le Rêve today. Indeed, Matisse's garden inspired several motifs found inside the chapel, including the flowers that surround the Virgin. 'I've had these flowers inside me for years,' he said, 'I'd seen them in the flowerbed in Vence.' I wonder, too, whether they also grew out of his memories of the magnolia trees, 'leafless but in blossom . . . like the Virgin's cloak', that he had encountered in the aftermath of his operations in Lyon. In the autumn of 1941,

Matisse had painted *Still Life with a Magnolia* in honour of his recovery, with a magnolia flower presented like the Madonna against an intense red background. Now, towards the end of the decade, his recollection of the magnolia trees in Lyon bloomed into his large mural of the Virgin against a backdrop of flowers – a little like a glorious cloak.

According to Paul Bony, the craftsman who executed the windows in the chapel, Matisse was 'implacable' when it came to choosing specific shades of colours for the stained glass. 'I am looking for something that is perilous,' Matisse said. 'I almost want it to grate.' Given the absence of red inside the chapel, and his quest for serenity, this may sound surprising. But Matisse's remark, as recollected by Bony, is consistent with his desire for the colours in the chapel to act upon the viewer's feelings with 'force'. Anyone who has watched sunlight illuminate the *Tree of Life* will understand this. Burning with the intensity of a flame, each pane of glass traps and retains light very effectively. The colours become almost palpable, like translucent segments of fruit about to burst with juice. Matisse was right: the experience of looking at the windows is the chromatic equivalent of a sharp blow on a gong. After a while, the brightness starts to feel as though it is imperilling the eyes. Somehow, though, this concentration of light feels like an appropriate analogy for the fervour of religious rapture – an effect augmented by the apparent motion of the yellow cactus flowers, which seem to

glide upwards as they glow, like Chinese lanterns released into a deep blue, twilit sky.

Creating the windows involved technical difficulties. Finding the correct shade of yellow, for instance, proved tricky. 'Here is the situation concerning the stained-glass window,' Father Couturier informed Matisse in May 1949. 'We have the blue and the green. Things aren't as simple for the buttercup yellow: the first experiments at backing it with frosted white weren't successful: the frosting kills the brilliance of the yellow and the result is a yellow grey. We're now trying another solution: frosting the sheet of yellow itself. We'll have the result the day after tomorrow.'

Creating the ceramic murals wasn't straightforward either. Stimulated by a display of 600 painted plates and pots that Picasso exhibited at Antibes in March 1948, Matisse – who had decorated ceramics long before, in Collioure – decided to entrust his tiles to the Spaniard's ceramicists in Vallauris, near Cannes. However, transferring the black lines of his drawings on to the white glazed background of the tiles proved complicated. Then, in August 1949, three quarters of a batch of tiles cracked during firing.

Picasso travelled to Nice to comfort his old friend – despite reservations about what Matisse was trying to do. Secular Picasso could not understand why Matisse would want to decorate a chapel. In fact, the whole endeavour made him angry. 'Picasso was furious that I'm doing a church,' Matisse confided to Father

Couturier over the summer of 1948. '"Why don't you do a covered market instead? You could paint fruit, vegetables." But I don't give a damn about fruit and vegetables: my greens are greener than pears and my oranges more orange than pumpkins. What would be the point? He was furious.' In part, Picasso's rage was fuelled by jealousy. According to Matisse's assistant Lydia, Picasso heard rumours that the Virgin and Child were inspired by his lover Françoise Gilot and their new daughter, Paloma – although Jacqueline Duhême, Matisse's model and assistant between July 1948 and August 1949, has also claimed that the Virgin was based on her. At the start of 2014, I travelled to Paris to meet her. 'What Matisse liked was that I had a pointy face, but he felt that the Virgin needed a full bosom, which I did not have,' she said. 'So he would say, "You mustn't lose weight, you must eat these little biscuits, Jacqueline." He would leave delicious little biscuits lying around everywhere to tempt me – which I loved.'

It is also possible, though, that Picasso felt threatened by the ambition of Matisse's chapel. Matisse wasn't frittering away his time on a single decoration; he was creating an entire building – a complete artistic and architectural environment. What could Picasso do to compete? The answer came the year following the dedication of Matisse's chapel, when Picasso began initial sketches for the murals *War* and *Peace* that would eventually decorate his Temple of Peace in a deconsecrated Cistercian chapel in Vallauris.

On 12 December 1949, the Bishop of Nice laid the

cornerstone of the Chapel of the Rosary. A year later, the stained-glass windows were in place. Matisse completed the murals by placing the rectangular white tiles flat on the ground and painting directly on to them using a brush, which allowed him to vary the thickness of his line in order to create a calligraphic effect, recalling the pages reproducing his handwriting in *Jazz*. By the end of 1950, with the principal elements of the chapel under control, Matisse could turn his attention to the design of the chasubles: ornate, cape-like vestments worn by priests while celebrating Mass or the Eucharist. He finished these in 1952, having created twenty-two full-scale cut-outs for six sets of vestments, along with smaller cut-outs for their accoutrements, including stoles, purses and chalice veils.

Concocted in consultation with Father Couturier, who provided advice about liturgical symbolism, Matisse's vibrant, semicircular cut-paper models for the chasubles are awash with crosses as well as leaves, stars, fish and explosive bursts familiar from his earlier cut-outs. They look like they were designed with a fiesta or a street carnival in mind, rather than a Christian place of worship. Take the *Red Chasuble*, which is worn for the feasts of Pentecost and Martyrs, providing the only instance of this hue within the chapel. (The colours of the other chasubles, which differ according to the liturgical season, are white, green, rose, violet and black.) Alfred Barr acquired the maquette for the *Red Chasuble* for the Museum of Modern Art in New York, along with five of the finished garments. On the front, against

a poppy red background, a constellation of small Greek crosses in black and yellow represents the martyrs whose sacrifices mirrored that of Christ, who is symbolized by an enormous lemon yellow Latin cross. The same three colours dominate the back, where more crosses for martyrs, along with yellow palm branches, teem around the tree trunk of Christ. Both sides are sensational: each element appears to quiver and dance, as though heated up and animated by the chromatic conflagration of the colour scheme. Even Picasso was impressed when he saw the models for the chasubles for the first time.

We know that Matisse was excited by his chasubles because in a photograph maquettes for four of them can be seen hanging like raucous flags or banners on the wall around the fireplace of his bedroom-cum-studio in the Régina. On the mantelpiece is Picasso's *Winter Landscape* (1950), which he had lent to Matisse at his friend's request. There is an odd resemblance between the spiky palm tree in the background of Picasso's painting and the crosses exploding with light in the two maquettes for a black chasuble that was never actually made. Perhaps this connection is the real reason why egotistical Picasso admired Matisse's chasubles: he suspected that he had influenced their design. As Matisse once said: 'Picasso is not straightforward.'

Matisse believed that his chasubles were integral to the full effect of the chapel, just as his sumptuous and colourful dancers' costumes were essential to the ballets that he had designed earlier in his career: a production

of *Le Chant du rossignol*, which opened in Paris in 1920, and *Rouge et noir*, which premiered in 1939. The chasubles offered a colourful contrast to the black-and-white habits of the nuns, mirroring the opposition between the windows and the murals, and introducing life and movement into an otherwise still space. Six of the chasubles are now kept in the chapel's sacristy.

When Picasso saw the finished chapel, he supposedly said that it reminded him of a bathroom. If this is true, then his spite must have been motivated by envy. After spending decades trying to create a painterly equivalent of light in his canvases, Matisse had finally managed to harness sunlight directly. Through his radiant windows, light gushes into the chapel, kissing the marble floor, caressing the murals, stroking the candlesticks, lamps and crucifix, and – most unexpectedly of all – casting a numinous magenta glow that shimmers and shifts across the various reflective surfaces. Under Matisse's direction, the light captured within his windows is resplendent and almost heavy, like a precious metal. Matisse was thrilled with the intensity of the colours generated by the windows. In particular, he loved a limpid reflected blue that reminded him of a spellbinding sulphuric explosion that he had engineered while staging the eruption of a model Vesuvius – using, of all things, colourful paper cut-outs – in a toy theatre as a schoolboy. 'When I go into the chapel, I feel that my whole being is there – at least everything that was best when I was a child,' he said.

In the past, Matisse had longingly painted open

doors and windows. The views beyond promised release from everyday life. In his chapel, however, portal and vista are as one: the window is the work of art. The *Tree of Life* hints at the hereafter, but it is also part of our world. Matisse used transparent glass deliberately in order to collapse the distinction between the interior of the chapel and outside. He had attempted something similar in a series of paintings earlier in the Forties. Back in 1946, having recovered some of his strength following his operations, Matisse had begun a sequence of canvases known as his 'Vence Interiors', because they were created in his villa in the hilltop town. Characterized by fiery colours and flattened space, these pictures were his last sustained achievement as a painter. One of them was *Interior with an Egyptian Curtain* (1948), which juxtaposes the shrill pattern of Matisse's appliqué Egyptian cotton curtain with a view of a spiky palm tree seen through one of the windows of Le Rêve. Alfred Barr described it like this: 'In all Matisse's score upon score of views through windows the most astonishing is this explosive palm tree with its branches whizzing like rockets from the point where the black window mullions cross.' By the summer of 1948, though, when Matisse left Vence and returned for a few months to his apartment in Paris, he had exhausted the series. As his interest in the chapel waxed, so his appetite for painting waned. From that point on, with the exception of an unsuccessful portrait of Lydia in 1949, and two final paintings in 1951 – the last of which, *Katia in a Yellow Dress*, he did not

finish – he would never paint again. After more than sixty years, then, Matisse finally bid farewell to painting while completing the chapel at Vence. Still, some of the ideas that he had explored in the 'Vence Interiors' informed the chapel's design.

When the chapel was completed, Matisse was old and infirm. Long after the doctors who had operated on him in 1941 expected him to pass away, he was still persevering in the face of physical adversity, at times driven by nothing more than a cussed, bloody-minded instinct to keep on making art. 'Do I believe in God?' he wrote in *Jazz*. 'Yes, when I am working.' He had absorbed this work ethic during his upbringing among the diligent weavers and dye-workers of Bohain-en-Vermandois. Even though he wanted to escape his childhood home, it had served him well: Matisse's stamina was heroic.

What I find so brilliant about the chapel is the way that Matisse managed to sublimate all of the strain that went into its creation. Paradoxically, despite the intensity of its colours, there is also something soothing and hypnotic about the *Tree of Life* window, something serene – even though the man who created it suffered from abysmal insomnia and anxiety throughout his life. In defiance of his inner torment, perhaps even because of it, Matisse could still create a sanctuary of tranquillity. His chapel was almost a form of psychological self-defence. Constructing it required 'immense effort', as the artist said, but the finished effect was effortless. This, I believe, is the essence of Matisse.

In order to achieve this hard-won contemplative state, Matisse had a daily ritual, which was witnessed by his assistant Jacqueline. 'He would have to exercise his hands because sometimes they would ache,' she recalled in 2014. 'So the first thing I'd do in the morning would be to bring him a little basin of warm water. He would wash his hands, and I would then bring him a small, very dry towel. He would carefully dry his hands, and afterwards he'd put on a bit of talcum powder. It was a bit of a ritual, which moved me because it reminded me of Mass – when the priest washes his hands. It always reminded me of that. It was very touching.'

Many years earlier, in his first published essay, 'Notes of a Painter' (1908), Matisse had written: 'What I dream of is an art of balance, of purity and serenity, devoid of troubling or depressing subject matter, an art that could be for every mental worker, for the businessman as well as the man of letters, for example, a soothing, calming influence on the mind, something like a good armchair that provides relaxation from fatigue.' In later years, that paragraph would come back to haunt him. There was a time when people dismissed Matisse as a painter of charming but superficial pictures that catered to bourgeois fantasies. For these critics, his armchair analogy became a club with which to clobber him. Surely, their argument ran, art of the 20th century should have higher aspirations than mimicking the banal pleasures of sitting in a comfortable, well-worn piece of furniture? Yes, of course it should – and Matisse, whose pictures often crackle with undercurrents of unease,

would have agreed. With the Chapel of the Rosary, though, his dream of an art of balance, purity and serenity was finally realized. Life's stress and strife had not been forgotten: this is the point of the *Way of the Cross* mural, which Matisse described as 'stormy' and 'tempestuous'. Yet ultimately, as he told Brother Rayssiguier, Matisse wanted the chapel to be a place where people could leave their burdens behind – 'as Muslims leave the dust of the streets on the soles of the sandals lined up at the door of a mosque'.

How striking that in this analogy Matisse evoked Islam rather than Christianity. Indeed, the chapel is full of subtle allusions to Islamic art, which had fired Matisse's imagination ever since he had seen an important exhibition of its masterpieces, full of rugs, bronzes and Persian miniatures, in Munich in 1910, shortly before visiting the Moorish monuments of Seville, Córdoba and Granada. The crescent moons of the external spire, the latticework of the wooden door of the confessional, the *djellaba*-like cloak worn by Saint Dominic – it is almost as if Matisse, inspired by his memories of Moorish Spain and North Africa, wanted his chapel to transcend religious faith. It didn't matter what you believed in, or even if you were an out-and-out atheist: the chapel would still exert its soothing, calming influence upon your mind.

'Of all the great 20th-century artists, Matisse is the one most closely associated with beauty with a capital B or harmony with a capital H,' Nicholas Penny, the Director of the National Gallery in London, told me.

'That infamous quote concerning the armchair suggests that he was interested in putting the mind of the beholder into a type of higher relaxation, if you like – which is not what you associate with most forms of Modernism. Our conception of creativity is not to do with leaving you in a state of calm and delight, but this was once one of the great aims of art. Yet it hasn't been lost, because it was important for Matisse.'

As Matisse said during an interview in 1950: 'I believe my role is to provide calm. Because I myself have need of peace.' I find that very moving and noble indeed.

5
Nice

Following his return to Nice at the beginning of 1949, Matisse was hard at work on his designs for the chapel at Vence for several years. Somehow, though, despite infirmity, insomnia, concerns about his eyesight and diminished energy, he still managed to create other important cut-out works of art, several of which shared the vertical format of the chapel's windows. Indeed, in the wake of Vence, Matisse created cut-paper models for seven new stained-glass commissions. Paul Bony, who had made the chapel's windows, executed one of Matisse's designs, *Chinese Fish* (1951), in the dining room of the Saint-Jean-Cap-Ferrat villa of the artist's friend Tériade, who had published *Jazz*. In February 1952, Matisse completed a maquette for another stained-glass window on the theme of Christmas Eve. Commissioned by *Life* magazine in America, this upbeat composition, more than 10 feet tall, features a large yellow star at its apex, presiding over a number of smaller stars in black and white that tumble downwards towards wavy leaf-forms against backgrounds of green, orange, purple and magenta. It was displayed in the reception of the Time-Life Building at Rockefeller

Center in New York that December. 'It will bring to New York – that "city of cold light" – a taste of the brilliant and sun-warmed light of Nice,' Matisse told Pierre. He also wrote to Alfred Barr: 'If you have a chance to see it, you will agree with me that a maquette for a stained-glass window and the window itself are like a musical score and its performance by an orchestra.'

By now, of course, Matisse was famous around the world. At the end of 1949, *Life* had published an article about Matisse and Picasso under the headline 'The Old Men of Modern Art'. 'You saw *Life* – about French painters,' Matisse wrote to Father Couturier. 'It's really wretched.' The following year, the artist won the grand prize for painting at the Venice Biennale, where he exhibited alongside the French sculptor Henri Laurens. Then, in November 1951, an important retrospective of Matisse's art, including seventy-three paintings and thirty-one sculptures, as well as drawings, watercolours and prints, opened at the Museum of Modern Art in New York, where it attracted 125,000 visitors. The cover of the catalogue reproduced a bespoke cut-paper design embellished by Matisse. So did the dust jacket of Barr's accompanying publication, *Matisse: His Art and His Public* – a sign that the paper cut-outs were being taken seriously, in America at least.

Back in France, however, Matisse still felt that he had to make a case for his cut-outs. They looked so simple, so childlike, that, to begin with, they were often dismissed. Were they trivial distractions that

eased Matisse's insomnia – or, worse, the ravings of a senile man? In 1949, Christian Zervos, the co-founder and director of the French journal *Cahiers d'Art* and a supporter of Picasso, reviewed an exhibition in honour of Matisse's upcoming eightieth birthday at the Musée National d'Art Moderne in Paris. Included in the show were twenty-one paper cut-outs – the first time that the results of Matisse's new 'system' had been exhibited in France. Zervos wrote: 'I refuse to consider these paper cut-outs as an artistic event . . . I will say more: all these paper jokes are so unworthy of Matisse that there is no point talking about them . . . At most they could be used to decorate textiles or wallpaper.'

Accordingly, in the first half of 1950, with the help of a stylish young woman called Paule Martin, who modelled for the artist before becoming his principal workshop assistant between 1949 and 1952, Matisse made two remarkable paper cut-outs that were conceived as a challenge to the primacy of oil painting. Like other cut-outs from this period, both were large, upright and rectangular. But, while compositions such as *Snow Flowers* (1951) incorporated Matisse's familiar meandering algae, and *Vegetables* (1951) was nicknamed 'The Leek' on account of the triumphant green shape dominating its right half, this particular pair of works represented a return to one of the central themes of the artist's career: the female figure.

Matisse often lived with his cut-outs for weeks or months on end, studying their visual rhythms, scrutinizing tiny details and instructing his assistants to move

bits around until he was satisfied. He even slept sur-
rounded by his work. In the case of *Zulma*, though,
which he created early in 1950, Matisse completed the
piece quickly, in just a couple of days. He used to say
that he couldn't begin painting until he felt like stran-
gling somebody – such was the state of strain and
nervy, pent-up energy that was necessary before he
could produce a half-decent work of art. But on the
afternoon he began *Zulma*, he was in a buoyant mood,
which found an outlet in its rapid, fluent composition.
According to Paule, who assisted Matisse on *Zulma* in
the absence of Lydia, who was fulfilling duties on the
artist's behalf in Paris, he was sitting in his wheelchair
in his bedroom, feeling 'cheery and relaxed'. Having
made a preliminary drawing, he started by cutting out
the blue form of a standing woman, facing the viewer.
Here was a glimpse of the blue figures that would flow
from Matisse's scissors during his *annus mirabilis* of 1952.
Next, he instructed Paule to slide sheets of yellow and
green behind his latest vision. The striking strip of
orange, which cascades like molten lava down the
woman's front, came later. So did Matisse's brush-and-
ink strokes, which define her lower abdomen as well
as the billowing contours of her inside legs.

Overnight, Matisse mulled on what was lacking from
the composition. When Paule returned the following
morning, he asked her to add some coloured paper that
he had cut to conjure the impression of a table topped
with purple. 'Finally came the blue and sienna vase with
its bouquet outlined in soft lead pencil,' Paule recalled

in 2013. 'We had finished in two days.' On her return, Lydia was surprised to find a tall and seductive blue stranger greeting her on the wall. 'By way of congratulating me,' Paule said, 'she and Matisse asked me to christen her. I was passionate about the local novelist [Jean] Giono's work at the time, and Zulma was a character in his novel *Que ma joie demeure*. And so it was.'

In certain respects, *Zulma* is unusual. Unlike Matisse's cut-outs that favour an 'all-over' effect, in which forms float freely against blank backgrounds, *Zulma* draws upon the structural devices of earlier oil paintings. In particular, it recalls the composition of Matisse's small painting *Pink Nude, Red Interior* (*c.* 1947), in which a naked woman with high breasts and a featureless face, like Zulma, also poses in between two pieces of furniture. The twin tables upon which Zulma rests her hands help to articulate a sense of space, so that we understand we are looking at someone standing in a room. Moreover, unlike other cut-outs where there is no distinction between colour and line – which is why Matisse described the process of making them as 'drawing with scissors' – here he drew on top of the sheets of paper to enhance the illusion of form. The bouquet to the woman's right, erupting in a rampant spray of zigzagging lines, is a cut-out version of a still life, anticipating the not dissimilar outline of the leek in *Vegetables*, which also has a cylindrical bottom half supporting a kind of blooming cone above. As for Zulma herself, aside from the sleek, almost Art Deco styling of her black hairdo-cum-helmet surrounding the flat,

vase-like shape of her face, she is a throwback to the
fantastical odalisques that Matisse was painting in Nice
during the Twenties.

In those pictures, Matisse offered up half-naked
models wearing diaphanous costumes, alongside plants,
bouquets of flowers and bowls of fruit, within interiors
awash with vibrant patterns. The ensembles were
meant to evoke Oriental harems or brothels. In *Zulma*,
the original blue form became by the end a lustrous
chiffon robe, clinging to the woman's curves. Open
down the middle, it exposes her private parts, recalling
a seated nude, also with a dark bob, wearing an entirely
open blue-fringed yellow robe, which Matisse had
painted in 1933. Yet the mood of *Zulma* is very different
to that of the Twenties odalisques, who swoon submis-
sively as though waiting, half drugged, for future
clients. Zulma is less languorous and more brazen and
austere: the madam of the harem of Matisse's imagin-
ation, perhaps, rather than one of its biddable girls.
More than 7½ feet tall, she has the grandeur and stark
formal simplicity of ancient Egyptian statuary.

The interplay between the orange streak of nudity
and its blue sheath is also beguiling. It is almost as
though we are looking at two women: a willowy pres-
ence emerging out of a fuller figure's embrace – or, if
you prefer, a single character's effulgent spirit irradiat-
ing the darker forms of her flesh. The orange is like a
fuse, the touchpaper of desire igniting the otherwise
cold blue body of an ice queen. Matisse was very proud
of *Zulma*, which was one of his favourite works. Two

or three years later, he used a similar pose in *Nude with Oranges*, in which several bright cut-paper orbs represent the fruit with which he was especially associated, since he had painted it on so many occasions: indeed, the French poet and art critic Guillaume Apollinaire once compared Matisse's art to an orange. These flank a naked woman rendered in smooth, swift strokes using a brush and ink. Like Zulma, she is seen from the front. She also has heavy-set shoulders, thick arms and high, spherical breasts.

In June 1950, Matisse produced another cut-out woman who, like Zulma, was fashioned in a very short space of time. She also appeared against rectangular swatches of flat colour. The treatment of her figure, however, could not have been more different. Whereas *Zulma* has a forbidding, static quality, his *Creole Dancer* explodes with vigour and jangling excitement. It is astonishing that an eighty-year-old invalid could have summoned her at all, let alone having done so in the course of a single day.

Against a loose grid of rectangular sheets of paper coloured by turns red, peachy orange, yellow, blue and black, as well as various shades of pink from salmon to coral to puce, a spindly green dancer leaps and twists. Her oval face, visible in the top-right corner of the composition, contains a blue splodge for a mouth, seemingly agape with surprise, as well as black eyes surrounded by jagged white stars. These represent her flickering eyelashes, but also add to the generally energetic atmosphere. On her forehead, she wears a

distinctive pointy black-and-white headdress that, from a certain angle, also resembles a beak. In fact, the thin, curving green forms that create the woman's arms have something of the property of wings, so that there is an avian quality to the rest of her, too. With her strange blue-and-white ruff and tutu-like skirt, she could be a bird showing off colourful plumage.

Like so many of Matisse's cut-outs, the picture also has a plant-like aspect: the spiky fronds of her costume, coupled with the green hue of her flesh, call to mind the palm trees that are commonly seen in Nice. In contrast to the geometric background, with its horizontal and vertical lines, Matisse arranged his dancer in a striking diagonal, so that she appears to lift off from the bottom left of the picture, before propelling herself upwards, spiralling and pirouetting, like some kind of jack-in-the-box made of flower petals erupting before our eyes. It almost appears as if she is about to break free from the background: indeed, three fluttering strands of her tutu extend beyond the left-hand edge of the planes of paper against which she was originally pinned, like a rare dragonfly. If *Zulma* is characterized by poise and hauteur, *Creole Dancer* is all freewheeling flirtation and licentious abandon. Matisse compared making cut-outs to the sensation of flight. In a sense, then, his Creole dancer-bird is an exultant expression of the soaring freedom of the medium itself.

The composition grew out of charcoal sketches of a young dancer from the Nice Opera called Christiane, whom Matisse had hired as a model during late 1949

and early 1950. According to the poet Louis Aragon, though, *Creole Dancer* was really inspired by the American choreographer and dancer Katherine Dunham, whose black dance revues incorporating African and Caribbean rhythms had been popular during the Forties. It is possible that Matisse had seen Dunham perform. Either way, we know that he was transfixed by America, ever since his initial visit there in 1930. 'The first time that I saw America, I mean New York, at 7 o'clock in the evening, this gold and black block in the night, reflected in the water, I was in complete ecstasy,' he recalled. Upon his return to France, he listened to American music. In one sense, then, *Creole Dancer* is a paean to America's contagious energy. This is why the bottom portion of the picture, with its bold blue and red, as well as two white stars echoed by the dancer's eyelashes above, recalls the Stars and Stripes.

More importantly, *Creole Dancer* also drank deep from the well of inspiration that had first sustained Matisse during his heroic years as an avant-garde artist during the early 20th century: dance. Matisse had painted dancers on a number of important occasions, ever since *The Joy of Life* (1905–6), a blisteringly strange Arcadian vision featuring a ring of six distorted nude nymphs whirling in a wild and raucous jig. This was inspired by a traditional Catalan peasant dance known as the *sardane*, which Matisse had seen performed by a group of fishermen on the beaches of Collioure. He returned to the theme in 1909–10, when the wealthy Russian collector Sergei Shchukin, who eventually

owned thirty-seven Matisses, commissioned him to paint two enormous murals to adorn the staircase of his Moscow mansion. In one, known as *Dance (II)*, five naked figures reprise the *sardane* from *The Joy of Life* – but this time they are gigantic maenads, stomping across a canvas almost 13 feet wide. 'I drew the whole thing whistling and singing a *farandole* [a lively Provençal dance] that had swept us along at the Moulin [de la Galette],' Matisse once said, recalling visits to the cabaret in Montmartre. The dancers themselves, though, were unlike any revellers he had encountered in Parisian nightclubs. He coloured them an unnatural, otherworldly red – a hue so violent and intense that they appeared to glow, as though they were scorching-hot. There is something barbaric and primeval, almost demonic, about *Dance (II)* and its companion panel, *Music*. The way that they dominate a room is frightening. Arguably, Matisse never created anything as powerful as these Modernist paintings again – although he came close when he painted another group of dancers somersaulting through space for Albert Barnes in the early Thirties. *Creole Dancer* is less threatening and more charming than *Dance (II)* – but it attests to Matisse's lifelong interest in this theme.

Matisse's passion for dance was clearly linked to his passion for women. He obsessively drew, painted and sculpted female models throughout his career. As a result, there has been a great deal of speculation about his romantic life. For instance, it used to be a commonplace among art historians that Matisse was cheating on

Amélie with the young women whom he painted as odalisques in Nice during the Twenties – although no evidence of infidelity has ever surfaced. By the Forties and Fifties, when his studio was run by Lydia, the nature of Matisse's love life was even more ambiguous. Following his operations, was he sleeping with Lydia? 'I don't think it would have been physically possible,' Hilary Spurling, Matisse's biographer, told me. 'By this time, Matisse had had a colostomy, and he was only kind of half a man. Certainly it was as intense a relationship as two human beings can have. But, personally, I doubt if there was a physical expression – and I talked about it with her.' For Nicholas Serota, Matisse's artistic interest in women ultimately transcended sexual desire. 'What does it mean to draw the female form thousands of times in the way that Matisse must have done?' he asked me. 'What drove him to do it? It was about his feeling not just for the female body but also, actually, for the essence of human life.'

This echoes something that Matisse himself once said. Almost a decade before he created *Creole Dancer*, he explained his fascination with dance to the art critic Pierre Courthion: 'It's the best thing in the world. I'm not talking about the kind of excitement that made me dance the whole night through, because I found young girls prettier that way. And not dance halls either. I'm talking about the eternal dance that's rejuvenated humanity down the ages; it makes happiness more intense, disasters more bearable, and saves us from sadness and despair. Instead of mourning disasters, why don't we dance them out? Dance is such an expressive

language.' Dance, for Matisse, was something ancient
and eternal. It wasn't an ephemeral dalliance with a
pretty girl – though that could be pleasurable, too –
but the powerful, primitive peasant dance that he had
witnessed on the beach at Collioure.

According to Matisse's model and assistant Jacque-
line Duhême, the artist would occasionally listen to
music while he worked – 'he preferred classical music,
something joyful, that danced.' Jacqueline enjoyed
dancing herself, and whenever the radio played a tune
that she couldn't resist, she would start to sway. 'And he
made little sketches,' she recalled in 2012. 'That really
pleased him a lot.' On one occasion, while Matisse was
still living at Le Rêve, the French prima ballerina Yvette
Chauviré visited and danced for him, to his delight.
Jacqueline witnessed this informal performance, to
which she cast her mind back during an interview first
published in 2014: 'It was quite impressive, I must say,
because when we look at dancers, it always seems so
aerial and light, but when they stand just 3 metres
away, you realize all the work it requires. You hear the
noise of the feet and pointed toes. Matisse was very,
very interested in this. He would say, "You see, Jacque-
line: everything is an effort. Even when one looks so
light, it is still hard. Everything is hard!"' There is
something tremendously poignant about a sickly artist
finding inspiration in the aerial lifts and pirouettes of a
professional dancer performing for him in private.
Moreover, it is telling that Matisse found within her
performance an analogy for his own thoughts about

making art. 'Even when one looks so light, it is still hard': although it was not yet finished, Matisse could have been talking about his chapel at Vence, which required so much effort, but ended up looking so light.

Like *Zulma*, Matisse was very fond of *Creole Dancer*. When his art-dealer son Pierre saw the work for the first time in his father's studio, he asked if he could buy it. Matisse considered Pierre's request, but eventually refused. Perhaps he regretted letting *Zulma* leave his studio so quickly: it was sold to the Statens Museum for Kunst in Copenhagen shortly after its creation. At the beginning of 1952, he wrote to his son to explain why he did not want to part with *Creole Dancer*: 'I think that it has an exceptional quality, and it is both agreeable and useful for me to keep it by me – at any rate, for a certain time. Do not infer from this that I want to do it all over again. I simply want to tell you that I am not certain that I can do any more work of that quality, in no matter what medium, and for that reason I want to hold on to it.'

This letter is important because it suggests that Matisse considered *Creole Dancer* the equal of his paintings. It also reveals that, although it was executed in June 1950, Matisse was still using the picture as a point of reference more than a year and a half later. I suspect that it became a talisman for him, a sort of sorcerer's apprentice or familiar in the studio: something he could turn to in times of crisis or when he was feeling tired, in order to seek inspiration and draw energy.

Moreover, when he told Pierre that he did not want

to 'do' *Creole Dancer* 'all over again', he wasn't being entirely honest. Later that year, in April, while it was raining over Nice, he began another cut-out dancer known as *The Negress*, this time inspired by the American entertainer Josephine Baker, whose erotic performances had electrified France during the Twenties and Thirties. The relationship between the two works is obvious: after all, *The Negress* paid homage to a performer who was sometimes known as the 'Creole Goddess'. Just as Pygmalion fell in love with his beautiful ivory sculpture, whose hardness yielded to his touch at the bidding of the goddess Aphrodite, so Matisse adored *Creole Dancer*, which in a sense was granted a fresh, more rampant lease of life in its successor.

Nearly 15 feet tall, the Negress figure is formed from just a few simple black shapes, including ovals for her head and stomach, and a triangle for her bust. At last, Matisse had fashioned a dancer who could crush the supernaturally large demon-nymphs that he had painted in his mammoth panel *Dance (II)* more than four decades earlier. Indeed, his Negress was so large that her legs extended beyond the wall and on to the skirting board, culminating in whopping triangular feet that rested upon the herringbone pattern of the studio's parquet floor. She stands mid-shimmy, facing the viewer, her legs angled towards her right, with her left heel raised off the ground, suggesting movement. She appears to be holding two puce palm fans, presumably props in her exotic routine. Beneath her belly, an orange grass skirt hangs from her waist, barely covering

her plump haunches. Two twisting black lines, like old-fashioned telephone cords, descend from her skirt: rippling liana plants, trailing between her thighs.

According to Paule Martin, '*The Negress* was created in a single movement, with the master in a great state of jubilation.' Later that day, Matisse's homoeopathic doctor arrived, looked her up and down and laughed. 'What's that dribbling between her legs?' he asked. Paule attempted to smooth over the awkwardness of the doctor's innuendo at once. 'I was afraid things would take a bawdy turn, and exclaimed loudly: "It's the liana of the grass skirt."'

In the autumn of 1952, though, *The Negress* still wasn't complete – at least, it wasn't in the state that it is today. There is a colour photograph of Matisse's studio that we know was taken on 13 September, because we can see a calendar on a small bookcase in the fore-ground, in which the artist, wearing dark glasses and possibly dozing, is slumped in bed, with *The Negress* in an intermediary state on the far wall beyond him. In another photograph taken that year, in which *The Negress* is also visible, Matisse can be seen sitting bare-foot in his wheelchair, wielding his shears, surrounded by a jumble of paper leftovers from which cut shapes have already emerged. Both pictures are reminders of Matisse's ailing physical condition. In one, he is in bed, even though sunlight enters through the windows. In the other, he is in a wheelchair.

Yet, as he grew weaker and approached the end of his life, his cut-outs continued to become bigger and

bigger. In its final incarnation, *The Negress* spread out-wards for more than 20 feet, taking over an entire wall of Matisse's bedroom-studio. To the figure of the dancer, Matisse added three 'birds', created using crescents similar to the black paper shapes that formed her arms. He also included several four-leafed patterns, import-ant motifs that recur in two other massive cut-out works, completed, like *The Negress*, in 1953: *Large Decoration with Masks* and *Decoration: Fruits*. Before he finished these compositions, however, Matisse would create some of the most famous works of art he ever made, during the course of a single, miraculously pro-ductive year.

One year was arguably more prodigious for Matisse than any other: 1952, when he was eighty-two years old. This was when he embarked upon a series of simple yet sensuous figures cut out of sheets of paper painted a single colour – blue. Since the very end of 1917, Matisse had been based predominantly in Nice, and at last the radiant azure of the sea and sky that he saw around him every day found glorious expression in his work.

By now, paper cut-outs had entirely superseded easel painting for Matisse. His studio, which he had already described as a 'factory' while working on the chapel at Vence, was like an assembly line for their efficient production. Assistants prepared, painted and stored coloured sheets of paper, which were sometimes pinned to the wall prior to cutting, turning the studio into a kind of walk-in palette. Using a range of scissors, some with points, others with rounded tips, Matisse then glided into these raw materials, in the words of the French poet and essayist Dominique Fourcade, 'like someone doing a sidestroke in a calm sea, without a wave, without foam'. The fantastical array of pared-down

shapes that he produced was pinned alongside his textiles and plants, in fluctuating designs of ever increasing size and complexity. Each shape was a sign, a purified essence extracted from reality: 'I have attained,' Matisse said, 'a form filtered to its essentials.'

We know that Matisse had been living for months, and in some cases even years, with these shifting forms decorating the walls of his living quarters and studio, which, by now, had gradually become one and the same space. He would endlessly arrange and rearrange them before deciding that a particular composition was complete. In order to manoeuvre his increasingly large shapes in an instant, assistants wore pincushions bristling with drawing pins, tacks and thin nails, carried hammers and scaled stepladders. Eventually, on Matisse's say-so, the shapes of coloured paper would be unpinned from their final positions and pasted on to a backdrop of white Canson support paper, which was then mounted on linen canvas.

With this system in place, Matisse could consolidate the radical developments of the paper cut-out technique that he had pioneered in the early Forties. Once an athletic man who had enjoyed sculling and horse riding, he was no longer fit enough even for simple outdoor pursuits such as swimming or strolling through a beautiful garden, so he constructed an alternative reality on the walls of his capacious, sun-filled studio, where he was free, in his imagination, to roam wherever he wished.

The most famous cut-outs from 1952 were the four

Blue Nudes that he began in April. With his work on the chapel at Vence finally behind him, Matisse could concentrate afresh on a subject that still obsessed him: the female form. Even though he never numbered it in his lifetime, the initial nude in the series is now known, confusingly, as *Blue Nude IV*, because, although Matisse began it first, he finished it last. A naked woman is entwined in a sinuous seated position, like a complicated yoga pose. Her right arm reaches back to cup her bowed head. Her left hand rests on the base of her right leg, which is wrapped around her left ankle. Her left leg twists upwards, away from the viewer, before returning to the foreground, where it culminates in a heavy foot with only three toes. Matisse constructed *Blue Nude IV* using a complex push-and-pull of opposing forces, as the arabesques of her body appear to follow impossible vectors.

The fascinating thing about *Blue Nude IV* is that Matisse was happy for the many traces of his hand to remain visible – like a mathematician so pleased with the elegance of an equation that he leaves up his complex workings on the blackboard in order to reveal how much effort was required for its discovery. The nude's shapely body is pasted on to a background of white paper, which appears to be clouding over with swirling charcoal marks. As for the paper itself, when you examine it up close, you find endless scraps and patches of varying sizes, painted in subtly shifting shades of ultramarine, reflecting the care that Matisse took while refining the contours of his subject.

In fact, the simplicity of the final image belies the length of time it took to make: Matisse worked so intensely on *Blue Nude IV* over a period of two weeks that eventually the strain began to tell on his assistant Paule. 'The first figure demanded such patience and attention on Matisse's part, but also from me, that it exhausted me and I was on the brink of collapse,' she recalled in 2013. 'He made me pin tiny squares of paper to enhance the curvature of the thigh or some other part of the body, then remove parts of the figure to remove colour strips, then set it back in place as my febrile fingers fumbled with the pins.' Bothered by her distraction, and irritated that she refused to catch up on her sleep, preferring instead to go out dancing, Matisse eventually asked Paule to leave the studio, after working with her for more than three years.

Five years earlier, in the text accompanying *Jazz*, Matisse had compared making cut-outs to 'the direct carving of sculptors'. His analogy feels particularly appropriate when considering *Blue Nude IV*, because its overall effect is remarkably sculptural. The various planes and facets of the bits of paper, layered on top of one another, create a tactile relief. Moreover, the poses of all four figures in the series recall a number of sculptures of nude women made by Matisse earlier in his career: it is clear, for instance, that while he was working on his *Blue Nudes* he was thinking of bronzes such as *La Serpentine* (1909), a standing female nude whose bendy limbs appear to have the flexibility of pipe-cleaners.

Perhaps he also had strong recollections of *Blue Nude: Memory of Biskra* (1907), a shocking canvas that earned him a reputation as an apostle of ugliness. Inspired by the muscular belly dancers of Biskra in Algeria, which Matisse had visited in the spring of 1906, this picture presented a large twisting, reclining nude, her body distorted and bulging, and formed out of aggressive, slashing strokes of indigo and ultramarine, against a decorative backdrop of curving palm trees. It was painted in response to a crisis in the studio, when a beloved clay model of a contorted reclining nude on which Matisse had been working for weeks smashed on to the floor. 'The sound of it falling and the shout I gave brought my wife rushing up from the room below,' he recalled. 'She found me still apoplectic, calmed me with a few words, and immediately took me out for a walk in the country.' The next day, full of the confidence that the sculpture had brought him, he took a big canvas and began *Memory of Biskra*. Forty-five years after this incident, as he drove on his assistant to keep pinning and moving the various paper fragments of *Blue Nude IV*, Matisse was once again like a sculptor kneading and teasing the clay of a model until he was finally happy with its form.

Once he was satisfied, though, he executed the other three nudes in the series in a flash. 'The other *Blue Nude* cut-outs came as explosions of inspiration during the same weeks,' Lydia recalled in 1977. Matisse cut them, she said, 'with mastery. Each on a different day, they had been cut with . . . one stroke of the scissor, in ten

minutes or fifteen at the maximum.' As a result, they
have none of the sense of labour and effort that charac-
terizes *Blue Nude IV*. There are no charcoal marks. The
bodies are flat and smooth, cut with assurance from
single sheets of paper. An important aspect of their
success is the way in which Matisse cleverly incorpor-
ated the white of the background into their forms,
sometimes emphasizing it by gently pulling apart
the pieces of paper on either side of an incision. In
doing so, he was 'drawing' with the negative space
of the background, creating the appearance of white
lines that helped to articulate, say, the curve of a
breast, or the crease of a leg folded beneath a knee. By
breaking up the potentially monotonous ultramarine,
these lines aerate the figures, producing an effervescent
effect.

With his *Blue Nudes*, Matisse was once again imagin-
ing the Arcadian realm that he had first painted in *The
Joy of Life*, in which naked women, goatherds, musi-
cians, dancers and lovers recline and embrace one
another in voluptuous poses replete with sexual satis-
faction. Matisse anticipated this return in 1951 when he
said: 'From *The Joy of Life* – I was thirty-five then – to
this cut-out – I am now eighty-two – I have not
changed . . . because all of this time I have looked for
the same things, which I have perhaps realized by dif-
ferent means.' Certainly, the sensuousness of the *Blue
Nudes* is undeniable. The four pictures are suffused
with an atmosphere of indolence and slow-burn

eroticism. The women appear gently to caress themselves, just as our eyes almost stroke the meandering knots of their limber bodies.

The *Blue Nudes* unleashed something powerful and primal within Matisse. As the year progressed, he added to his new cast of characters, who embodied the same celestial colour of the heavens that had so impressed Matisse when, in 1907, he saw it in the great early-14th-century fresco cycle by the Florentine painter Giotto in the Arena Chapel in Padua. ('Giotto is the height of my desire,' Matisse once told the French painter Pierre Bonnard.) Matisse cut a blue nude with pink gloves and green stockings, another with a skipping rope, and a third, this time a bather sitting among reeds. He created two blue acrobats, flipping themselves backwards, and an arching, leaping dancer known as *The Flowing Hair*, trailing streamlined fronds of blue. He produced a blue nude standing upright, both arms curled backwards behind her head to emphasize her breasts, and another called *The Frog*, with bent legs spread against a vivid yellow background. Above the door of the dining room in his apartment, he fashioned a frieze consisting of two blue women surrounded by several blue pomegranates and a couple of sinewy, mischievous blue monkeys. It is frisky and lascivious. Occasionally he used blue as a background: in *Venus*, where the white area in between two patches of blue becomes the silhouette of the goddess's torso; and in *The Snail*, the smaller of two works of art by Matisse with the same

name, in which a spiralling green form is pasted on to a blue piece of paper.

Matisse discussed the latter work in an interview with André Verdet in the same year of its composition: 'First of all I drew the snail from nature, holding it between two fingers; drew and redrew. I became aware of an unfolding; I formed in my mind a purified sign for a shell. Then I took the scissors.' Matisse's remarks offer a reminder of the intensive study of the natural world that was required before his scissors could create the seemingly simple shapes of his cut-outs. It was the same before he began his *Blue Nudes*: Matisse kept a sketchbook that he filled with preparatory studies, including more than twenty seated nudes – drawing and redrawing until he had perfected the 'purified sign' that he desired. 'In order to arrive at the simplicity of these bathers [Matisse's original title for his four *Blue Nudes*],' he told Verdet, 'a great deal of analysis is necessary, a great deal of invention and love.'

Matisse tried out temporarily several of his blue figures, including his *Blue Nudes*, *The Flowing Hair* and *Venus*, in a problematic area in the upper-right-hand corner of an ongoing and ever expanding cut-out mural called *The Parakeet and the Mermaid*, which eventually spread from left to right across two walls of his main studio. Eleven feet high and more than 25 feet wide, it is an environmental installation rather than a traditional work of art, consisting of scores of Matisse's distinctive seaweed-like leaf-forms, already familiar

from the *Lagoon* compositions of *Jazz*, the two *Oceania* panels and the *Tree of Life* window in the chapel at Vence. Moreover, like the *Oceania* wall-hangings, it adopts an 'all-over' approach. By now, Matisse was so adept at creating his large leaves that he could sweep his heavy scissors through sheets of paper without stopping to check how he was getting on: he had internalized the shapes he wanted to such an extent that cutting them out had become automatic. In among *The Parakeet and the Mermaid*'s thick leaves, which are many different colours, including pink, red, orange, yellow and turquoise, as well as various shades of green and ultramarine, a cornucopia of blue pomegranates floats against white. Matisse was excited by the counterbalance between the colour of the forms and the whiteness of the background. He said that the whole thing was suffused with a 'white atmosphere' possessing a 'rare and impalpable quality' that he found 'expressive'. This is something that he had picked up from non-Western art. 'I had noticed that in the work of the Orientals the drawing of the empty spaces left around leaves counted as much as the drawing of the leaves themselves,' he said in a letter to André Rouveyre in 1942.

On the left-hand side of *The Parakeet and the Mermaid*, we see a sleek ultramarine form that is the bird of the title. 'You see, as I am obliged to remain often in bed because of the state of my health, I have made a little garden all around me where I can walk,' Matisse

told Verdet. 'There are leaves, fruits, a bird. Restrained movement, calming.' On the right, though, we find another blue shape, consisting of three pieces of paper cut with great skill from a single large sheet to evoke a mermaid. Wriggly, slick and lubricious, she recalls *The Knife-Thrower* in *Jazz*, as well as the dancer in *The Flowing Hair*. Her presence renders the location of the ensemble ambiguous, turning the parakeet's tropical forest into an underwater garden: the coral reef of her watery domain. Matisse's 'little garden', then, also evoked memories of Tahiti, which he described to Verdet in 1952: 'The leaves of the high coconut palms, blown back by the trade winds, made a silky sound. This sound of the leaves could be heard along with the orchestral roar of the sea waves, waves that broke over the reefs surrounding the island. I used to bathe in the lagoon. I swam around the brilliant corals emphasized by the sharp black accents of holothurians [sea cucumbers]. I would plunge my head into the water, transparent above the absinthe bottom of the lagoon, my eyes wide open . . . and then suddenly I would lift my head above the water and gaze at the luminous whole.' *The Parakeet and the Mermaid* fuses together these various sensations, at once evoking the rustle of coconut palms and waves breaking over coral reefs, as well as swimming among Tahiti's luminous lagoons.

While he was working on *The Parakeet and the Mermaid*, Matisse was also creating another room-sized mural called *The Swimming Pool*, assembling it in his

dining room in the Régina – a grand space with an
ornate mantelpiece and a chequerboard tiled floor –
where he worked on it only during the evenings. In
this seductive frieze, which was the climax of his series
of blue figures, frolicking female swimmers splashed
and swam within a white band extending out along the
fabric-covered walls from either side of the glass doors.
Lydia traced the origins of this vast work of art back to
one morning when Matisse announced that he wanted
to see some divers. 'We called up the usual rental car
and he was off to Palm Beach at Cannes,' she recalled.
'We arrived there just at midday. Blazing sun! And not
a swimmer at the pool! H.M. laughed and, having
taken scarcely a few steps along the pool (of modest
dimensions), he gasped to me: "Let's leave quickly:
with this sun, I will get sick." Once returned to the
house, he said: "I will make myself my own pool." And
he had me place on the walls all around the room where
he lived a band of white paper 70 centimetres wide at
the height he indicated.'

On to this band, Matisse began arranging his swim-
mers, cut – of course – out of sheets of paper painted
blue. Some of them speed along performing front
crawl. Others favour backstroke. A few of their com-
panions dive in and out of the water, while one or two
appear to hurtle and back-flip through space, more like
trapeze artists than swimmers. These vigorous athletes,
who resemble the thrusting nudes we find in *The Flow-
ing Hair* and *The Parakeet and the Mermaid*, almost
leave the central white band of 'water' altogether, and

threaten to escape into the weightless limbo of the surrounding tan wall-covering. Starfish, a sweet little dolphin and droplets of displaced water animate the composition.

To the far left, Matisse created his final swimmer by turning the 'negative' of the white background into a 'positive' form by surrounding it with artfully arranged blue paper – a technique he also used that year in *Venus*. This inversion of the blue-on-white forms of the earliest swimmers to the right only adds to the general sense of potential and flux. Previously in his career, Matisse had been obsessed with Paul Cézanne's blue-tinged oil painting *Three Bathers*, which he acquired from the French dealer Ambroise Vollard and owned for almost forty years before giving it to the city of Paris in 1936. In *The Swimming Pool*, Cézanne's solid bathers have become the freewheeling nymphets peculiar to Matisse's imagination. 'I have always adored the sea,' he said, referring to this work, 'and now that I can no longer go for a swim, I have surrounded myself with it.'

Almost 54 feet long, *The Swimming Pool* reflects Matisse's preoccupation with scale as he approached the end of his life. That summer, he began two monumental masterpieces that were among the most abstract works of art he ever made. One was *Memory of Oceania*, a view across the harbour in Tahiti, with a sailing ship represented by a diagonal green rectangle and a fuchsia mast. The other was a second paper cut-out called *The Snail*, which is much more famous than its predecessor.

While writing this book, I visited the Tate's stores in London to watch a conservator working on *The Snail*. A giant square with sides measuring nearly 9½ feet, it contains eleven blocks and wedges of coloured paper, arranged in a loose spiral, within an irregular orange border. The various elements are pasted on to two enormous sheets of white backing paper and mounted on canvas. All of its colourful rectangles and rhomboids make me think of a string of Himalayan prayer flags flapping on a sun-soaked mountain peak.

Looking at it in the gallery's stores was a strange way to experience one of the most popular works of art usually on permanent view at Tate Modern, because it was laid flat, resting on packing crates a few feet off the floor. Taken out of its frame, and with no protective glass in between the cut paper and me, it exploded with colour. According to the conservator, the gouache hasn't faded at all since it was applied. I was reminded of Derain's description of the Fauvist canvases of 1905, which detonated colours like sticks of dynamite primed to discharge light. Here was a chromatic fireball, incandescent with orange, red, yellow, green, blue, black, lilac and mauve. I felt like Matisse while he was working on the bright illustrations to *Jazz*: I needed sunglasses. Vincent van Gogh once said: 'The painter of the future will be such a colourist as has never yet been seen.' That triumphant colourist of tomorrow was Matisse.

At first glance, the intense, saturated colours jangle, grate and clash. Each hue is so loud, so strong – they simply should not go together. And yet, in Matisse's hands, they come together as one. In order to ensure that the opposing factions of these skirmishing pigments made peace, Matisse had to draw upon his long experience as a painter, as well as on his innate sense of how to blend and tame colour. Somehow, for instance, towards the top of the composition, a rectangle of black soars effortlessly through space. How did Matisse manage to make such a ponderous shade appear so weightless? Black shouldn't be able to defy the chromatic equivalent of the laws of gravity in this fashion, but, in *The Snail*, it does. He often compared himself to a juggler, and, more than any other work, *The Snail* feels like his consummate circus act, with its multicoloured balls kept spiralling high in the air.

Of course, the size of *The Snail* is also integral to its success, since it ensures that the impact of the work is fierce. Picasso's partner Françoise Gilot, who visited Matisse on several occasions in the Forties and Fifties, once told me: 'Matisse wasn't called a wild beast for nothing. In a sense, he was like a lion. He was wild. He was somebody who used the strong emotions, not the soft ones. He shook you up.' As a result, for me, the title of *The Snail* is misleading. This work of art is the opposite of a soft and vulnerable creature hiding away in a shell. Rather, it is bold and rampant, a vigorous beast roaming the savannah. Moreover, while its title makes it sound methodical and slow-paced, one glance

will tell you that it was executed at speed, even if Matisse waited before signing and dating it until the following year. In several places, you can see that he ditched his scissors in order to rip into the paper instead, so that his immersion in a world of colour could be as immediate as possible. This physical aspect of *The Snail* is not remarked upon very often. Up close, as well as torn edges, it is possible to see scuffmarks, folds and creases, and lots of pinholes, suggesting that the pieces of paper were moved several times before Matisse resolved their final arrangement. Some of the colours are thicker and heavier than others, since the gouaches were painted with different degrees of intensity. The watermarks on the paper are still visible, too, as are the brushstrokes – up in one direction, down in the other, resulting in alternating stripes of lighter and darker shades, like a neatly mown lawn. All of this enhances the surface interest of the final work of art, adding to its effect. 'It's a very powerful three-dimensional form,' Nicholas Serota told me. 'It's not just flat colour: it's colour that comes and grabs you by the throat.'

Matisse had another title for this work: 'The Chromatic Composition'. Of course, this is less appealing than *The Snail*. But it is a more accurate description of what this piece – and indeed many of the cut-outs that Matisse had produced since the early Forties – was all about: the eruption of energy and light by smashing together colours like subatomic particles in a nuclear reaction. 'For me,' he once said, 'a colour is a force. My pictures are made up of four or five colours that collide

with one another, and the collision gives a sense of energy.'

The Snail may appear simple. If it weren't for its size, you'd be forgiven for thinking that a six-year-old child could have come up with it. But, as Serota put it to me, 'Frankly, if it were made by a child of six, and it was that powerful, we'd want to show it at the Tate.'

Epilogue

Two years before he died, in the late winter and early spring of 1952, Matisse created one of his final master-pieces, *Sorrow of the King*. It is among his most moving works of art, in part because it feels as though Matisse was bidding farewell to artistic themes he held most dear. Thirteen feet wide, and 9½ feet tall, it was his largest cut-out to date. Against a gridded background a little like the one in *Creole Dancer*, except this time dominated by blues and pinks, it presents three figures. In the middle sits a guitarist, dressed in a black robe decorated with light green flowers. To his right (our left), a green percussionist with frog-like hands and feet accompanies him on a drum or tambourine. To the guitarist's left (our right), a dancer cut from black and white sheets of paper pirouettes and twirls to the music. The supple central axis of her body is articulated by an undulating streak of orange, a thinner version of a similar strip that Matisse had used to define the figure's body in *Zulma*. Two curling forms swirl around her shoulders and her legs like hula-hoops or the rings around a planet. These suggest swift, gracious, delicate

movements, as one elegant black foot, arched and elongated on tiptoe, steps in front of the other.

Although we can't hear the guitarist's melody, we can see it, in the form of the yellow and orange leaves representing musical notes that levitate on either side of him before being drawn inexorably towards the dancer, by whose side they pool at the bottom of the composition. Matisse described the picture to Father Couturier like this: 'The sorrowful king, a seductive dancer, and a fellow strumming on some sort of guitar which releases a shower of flying saucers, the colour of gold, to go streaming round the top of the composition and end up in a mass around the dancer in action.' It is possible that Matisse was alluding to the biblical theme of David playing the harp at the court of King Saul to alleviate the ruler's suffering whenever an evil spirit tormented him.

According to Matisse's assistant Paule, who was photographed working on the composition beside a stepladder, *Sorrow of the King* took a long time to produce, requiring many cuts, additions and adjustments. 'The black open-work dancing figure was the first to appear on the wall,' she recalled. 'The yellow pirouetting leaves, which to their creator represented musical notes, came last, providing the full stop of the piece. The green character came after the imposing black mass sprinkled with green flowers, placed so that the guitar appears to be orchestrating the whole piece. When the panel was completed, Lydia exclaimed: "The master is playing the guitar, I'm playing the tambourine and Paule is dancing!"'

Lydia's remark was astute. The guitarist surely represents the artist inspired by his model, who appears in the picture as a dancer. Matisse, who was a gifted amateur violinist, painted musical instruments or their cases as surrogates for himself on several occasions. In *Sorrow of the King*, he returned to this idea, replacing his violin with a guitar. The guitarist's legs and feet are hidden beneath the curving bottom of his cloak – appropriately enough, since Matisse, who by now moved around his studio in a wheelchair, could no longer trust the strength of his lower limbs. Moreover, special emphasis is placed upon the bright white shapes of the guitarist's hands – as though Matisse wanted to acknowledge the dexterity of his nimble fingers, which had yet to fail him. There is little doubt that Matisse intended *Sorrow of the King* to serve as a metaphor for making visual art.

Yet, despite its bright colours, the presiding mood of the picture, as the title suggests, is melancholy – just as tragic notes underscored the joyfulness of *Jazz*. The musician's dark robe, reminiscent of several 'blunt luminous black' velvet jackets painted by Manet, which Matisse once said that he admired, gives him a funereal air. Here is a musician capable of producing a pleasing refrain, but who, with his head bent forwards, is also resigned to the fact that its beauty, and perhaps even his own abilities, will disappear once the performance is over.

The form of the dancer adds to this fleeting atmosphere. Constructed using white, her body has a permeable, semi-permanent quality, as though she is fading to

invisibility before our eyes. Part of the background is visible through her midriff and legs, which isn't the case with the other figures, whose presence is stronger, entirely opaque, and therefore less elusive. Even the downward trajectory of the musical notes, which end up in a heap like a pile of autumn leaves on grass, suggests that the tune may likewise be coming to an end. *Sorrow of the King*, then, is a wistful adieu to various themes and motifs that had sustained Matisse throughout his career: music, dance, patterned fabrics, the female form and colour.

Matisse was very proud of the finished picture: writing to Jean Cassou, of the Musée National d'Art Moderne in Paris, on 9 April 1952, he said, 'I consider [it] equal to all my best paintings.' He continued: '[*Zulma*], although of very fine quality, has neither the quality nor the breadth nor the profoundly expressive pathos of *Sorrow of the King*.' In a sense, the picture represents the final decade and a half of Matisse's life, which was always shadowed by pathos. He never forgot how close he had come to death in 1941. Following his recovery, he experienced acute physical distress that would have fatally hampered the ability of lesser artists to make art. Somehow, though, the limitations of Matisse's last years afforded him greater freedom as an artist than he had ever enjoyed before. In the teeth of suffering, he continued to experiment and explore. He said that he was like a man who after years of self-discipline had suddenly loosened his belt. When he cut into paper with a pair of scissors, it felt exhilarating, like flight.

Now his art appeared effortless – even though it required 'immense' effort to summon it. At last, he could achieve what he had set out to do decades before. 'There is no break between my early pictures and my cut-outs, except that with greater completeness and abstraction I have attained a form filtered to its essentials,' he said in 1951. Having spent a lifetime winnowing reality, sifting for the simple essence of his subject, Matisse had finally discovered what he was searching for during his 'second life' as an artist.

And yet something still eluded him. Towards the end of his life, Matisse hoped to win a substantial commission in America – perhaps even an equivalent of the chapel at Vence. After all, hadn't his recent retrospective at the Museum of Modern Art been a tremendous success? Towards the end of 1952, his son Pierre sent word that two American collectors, Mr and Mrs Sidney Brody, were considering commissioning Matisse to create a large ceramic work of art for a prominent open patio in their house in Los Angeles. Without consulting the Brodys, Matisse set to work at once. He was almost eighty-three, and yet he was still governed by the same animal instinct, plunging headlong towards what he loved, that had compelled him to become a painter in 1890.

In the months that followed, he produced three grand creations: *Large Decoration with Masks*, *Decoration: Fruits* and *Apollo*. The first of these, he wrote to Pierre in November, was 'a complete success': 'I think it will be my last work in this genre. I have given it all my

strength, and I shall not try to do anything better.' Like many of his cut-outs, *Large Decoration with Masks* evolved over time. At one stage, its central panel, containing a column of four rosettes surrounded by a wavy blue border, was photographed on his studio wall, sandwiched in between *The Snail* and *Memory of Oceania*. It appears that Matisse considered using this section of *Large Decoration with Masks* as part of a triptych, though this was subsequently rejected, pointing to the still fluid composition of the cut-outs even at this late moment in his career.

In the end, *Large Decoration with Masks* became a vast, tapestry-like work of art, with a grid of quatrefoils bound at either end by fluted pillars and two beautiful, brush-and-ink masks peeping out from the foliage like elusive woodland sprites. It was possibly inspired by an antique lavabo with a marble head that Matisse kept in the studio: a photograph survives in which the lavabo can be seen surrounded by decorative cut-out forms. In its resemblance to Islamic tiles, it also drew upon his memories of visiting the Moorish palace of the Alhambra in Granada. 'The combination of the masks and the flowers is something that has never been done before,' he wrote to Pierre on 12 November. 'It is such a consolation for me to have achieved this at the end of my life.' The enveloping scale of *Large Decoration with Masks*, *Decoration: Fruits* and *Apollo* anticipated the later developments of installation art. As Matisse told André Verdet in 1952: 'One day easel painting will no longer exist because of changing customs. There will be mural painting.'

When the Brodys visited Matisse in May 1953, the artist showed them *Apollo*. It was, in Matisse's words, a 'discouraging' encounter: 'They seemed to be completely unresponsive, looked at nothing when they walked around the apartment and were in no way stirred or enthused when they came to the maquette for their ceramic.' On a subsequent visit, though, they perked up, before asking Matisse if he could create 'something quite simple – a vivid scatter of colour on a white background'. In response, Matisse created *The Sheaf*, a large fan, 11½ feet wide, of the artist's familiar seaweed-leaves, blooming upwards with superabundant vigour.

Before 1952 was out, in addition to the Brody project, Pierre encouraged his father to embark upon another 'new adventure': a possible commission to create a stained-glass window and a bronze door for the mausoleum of the American businessman Albert Lasker, in Newport, Rhode Island. By April 1953, Matisse had created *Ivy in Flower*, a maquette for the mausoleum's window. 'I really think it's very beautiful,' he wrote to Pierre. 'It has a new harmony: on a background of buttercup-yellow frosted glass, I have laid a lot of big purple and green ivy-like leaves, with purple-violet seeds of ivy scattered in and out of them. It's very rich, and very beautiful. The square format is very good, too. And now I'm going to take a day or two off, so as not to get too tired, and then start on the grille for the bronze door.' The effusiveness of this letter betrays a note of uncertainty, as though Matisse

wanted to convince himself, as well as Pierre, that his creativity had not yet deserted him.

Sadly, the Lasker project never came to fruition. It dragged on and vexed Matisse for much of the penulti-mate year of his life. Mrs Lasker, who was considering commissioning the window and door from Matisse, did not like his stained-glass window *Christmas Eve*, which was shown in New York at the end of 1952. Eventually, despite seeing only a colour photograph rather than the original design, she rejected Matisse's *Ivy in Flower* on the grounds that it was 'all yellow'. 'I am simply furious that Mrs Lasker should have turned it down,' Matisse wrote to Pierre. 'It is a miserable business that I should be treated like this at my age, and with all my past work to speak for me.' Since 1941, Matisse had been living on borrowed time. The sensa-tion of having wasted some of his precious 'second life' was therefore especially irksome.

Moreover, by now, Matisse was finding it increas-ingly difficult to work. 'I don't think I can go on,' he had written to Pierre in November 1952. 'I'm terribly tired. My age is against me, I have asthmatic crises that are very exhausting and call on all my reserves to keep going. I give my doctors a lot of trouble, because they have to work on me "with their fingertips", as one of them used to say.' When his old model and friend, the nun Sister Jacques-Marie, visited Matisse in the sum-mer of 1954, she was shocked: 'I never expected to see him in such a state. There was nothing left of him but a

poor old man, hunched and huddled. It was as if he could no longer see, and could hardly speak. What had happened to my invalid, who had been so lively even in his eighties? Gone was the mischief in his eyes. I could not understand this terrible change, though I learned later that he had passed a bad night, with asthma and insomnia in combination.'

All his life, Matisse had been in a hurry. In the wake of his operations, as one of his models said, 'he had to economize his forces. It was a race, an endurance course, which he was running with death.' Following his phenomenal blaze of creativity in 1952, Matisse no longer had the energy to keep up his furious pace. Aside from the window for the Lasker mausoleum, he scaled down, working on covers for exhibition catalogues and a special edition of *Verve*, as well as a Christmas card for the United Nations International Children's Emergency Fund. His second life was almost over – but his powers had not yet entirely disappeared. That summer of 1954, when Sister Jacques-Marie found him hunched and huddled, the Swiss artist Alberto Giacometti made a dozen drawings of Matisse in the Hôtel Régina. Giacometti told Françoise Gilot that he was moved to find 'a great artist still so absorbed in trying to create when death was at his doorstep'. Matisse's unswerving, bull-headed desire to make art remained with him to the end.

'Nothing is more difficult for a true painter than to paint a rose, since before he can do so, he has first to

forget all the roses that were ever painted,' Matisse
had written in 1953, the year before his death. For his
final work of art, Matisse mustered all of his diminish-
ing strength to take on this artistic challenge. A cut-out
rosette with a border containing eight green pomegran-
ates, *Rose* was the maquette for a rose window
commissioned by Nelson Rockefeller in memory of his
mother. Alfred Barr acted as intermediary on the pro-
ject, over which negotiations began in March 1954. At
first Matisse refused the commission, citing his fragile
health. But by August, he felt up to it. On 4 November,
Barr received a letter from Matisse informing him that
the design was finished. The letter had been written
three days earlier, when Matisse also suffered a cerebral
micro-embolism. 'This is the end,' his doctor told Lydia,
after taking her to one side. While Matisse's last letter to
Barr was in transit to America, the artist solemnly
sketched Lydia one final time. She was wearing a towel
like a turban on top of her head after washing her hair.
'When he had finished,' Lydia later recalled, 'he gave me
the sheets of paper and the pen. Then he asked to see the
last of the four drawings once again. He held it before
him, not quite at arm's length. He looked it over,
severely. Then he said, "It's good!"' By the time that
Barr received Matisse's letter in New York, the artist
had died in his studio at Cimiez, on 3 November, at four
o'clock in the afternoon. At the moment of his death,
both Lydia and his daughter Marguerite were by his
side, just as they had been during his recuperation in
Lyon in 1941, when his second life had begun.

Author's Note

This book was written to coincide with the exhibition *Henri Matisse: The Cut-Outs* at Tate Modern in London and the Museum of Modern Art in New York. I am grateful to Tate Publishing for sending me an early draft of the accompanying catalogue. My short book, which is intended to provide for the general reader an overview of the development and significance of the paper cut-outs, is meant to complement rather than to compete with Tate's extensive exhibition catalogue, which is full of fresh scholarship and specialist insight into the art of Matisse's final decade. Along with a series of fascinating archival photographs that document Matisse at work amid the shifting appearances of his various studios in Paris, Vence and Nice, the exhibition catalogue also reproduces in full colour most of the artist's major cut-outs, with the exception of *Sorrow of the King*, which did not travel from Paris for the exhibition. In this respect, Tate's catalogue improves upon *Henri Matisse: Paper Cut-Outs*, which was published in connection with an exhibition of the same name that toured the National Gallery of Art in Washington, the Detroit Institute of Arts and the St Louis Art Museum

between 1977 and 1978. This exhibition was the first comprehensive retrospective of Matisse's compositions of painted, cut and pasted paper. The accompanying publication, which includes a full catalogue survey recording almost 220 examples of Matisse's paper cut-outs, remains a work of pioneering scholarship and an invaluable resource for anyone interested in the subject. However, the majority of the illustrations are reproduced in black and white, which is unfortunate, given Matisse's genius as a colourist.

While researching and writing this book, I also worked on *Henri Matisse: A Cut Above the Rest*, a television documentary about the artist's paper cut-outs that I presented for *The Culture Show* on BBC Two. I would like to thank the contributors who kindly agreed to be interviewed for the programme, including Matisse's former models and assistants Jacqueline Duhême and Paule Caen-Martin, both of whom I met in Paris; Hilary Spurling, who won the Whitbread Prize for the second volume of her brilliant two-part biography of Matisse, and who generously shared her exhaustive and authoritative knowledge about the artist with me in a wide-ranging, on-camera discussion lasting several hours; Nicholas Serota, the Director of the Tate, who spoke about Matisse with intelligence and passion; and Nicholas Cullinan, Curator, Modern and Contemporary Art, at the Metropolitan Museum of Art in New York, who co-curated *Henri Matisse: The Cut-Outs* for the Tate alongside Serota and Flavia Frigeri, Assistant Curator at Tate. I am grateful to Cullinan and Frigeri

for their enthusiasm for my book as well as for helping me to resolve several factual questions.

I would like to thank Georges Matisse, on behalf of the Henri Matisse estate, for kindly allowing us to film in the Chapel of the Rosary, and for his guidance and counsel on the project. Neither the programme for *The Culture Show* nor this book could have been made without the tireless support of Jeanette Ward, Tate's Senior Press Officer, and Cecily Carbone, Assistant Press Officer, Tate Modern, to both of whom I owe a great debt. I was very fortunate to work with Kate Misrahi, who directed *Henri Matisse: A Cut Above the Rest* for the BBC. I am also indebted to her for passing on transcripts of interviews conducted for the programme that I could then draw upon while writing this book. In addition, I would like to thank Daniel O'Connor, who researched the programme, and Janet Lee and Emma Cahusac, Series Editor and Series Producer of *The Culture Show* respectively.

After completing an early draft of my manuscript, I interviewed Nicholas Penny, the Director of the National Gallery in London, about the major exhibition *Veronese: Magnificence in Renaissance Venice*, which overlapped with *Henri Matisse: The Cut-Outs* in London during 2014. I was delighted when he shared his thoughts about Matisse with me during the course of our interview for the *Daily Telegraph*. Penny drew a comparison between Veronese's interest in beauty and that of Matisse, whom, he said, 'is sometimes an alarmingly tense painter, though, unlike Picasso, he is never really

interested in disturbing your fundamental ideas'. While I am not sure that I agree with the second half of this statement, it is certainly true that, more than any other great artist of the 20th century, Matisse was 'most closely associated with beauty with a capital B or harmony with a capital H', as I quoted Penny in the 'Vence' chapter. The wider context for this remark was Penny's thought-provoking observation that, in the wake of Modernism, it has become tricky to praise 'beauty' and 'harmony' in art, even though Western artists once hoped to achieve both concepts as a matter of course. 'It would be easier for critics today to say, "I left the exhibition feeling completely tortured or destroyed, or wrenched out of all my ideas" – that's what everyone wants to hear,' Penny told me, after invoking Matisse's 'infamous' quote about dreaming of an art of balance, purity and serenity that could provide relaxation from fatigue – 'something like a good armchair'. 'But for someone to say, "You know, I just felt it tranquillized me" – if you're not careful, that sounds awful. If you are delighted by Matisse's paintings, you know in yourself that it is a higher form of sensation than merely being tranquillized or relaxing in an armchair, but it's quite difficult to talk about.'

Henri Matisse: A Cut Above the Rest was not the first programme about Matisse that I had made for the BBC. In 2009, I filmed *Modern Masters*, a four-part series about modern art that was broadcast on BBC One the following year. One of the episodes was devoted to

Matisse, and I was thrilled to work on it with my director, Mark Halliley, who, once the shoot was over, generously gave me his annotated copy of *Matisse on Art* (1973), an indispensable compendium of the artist's most important statements, with the exception of his letters, edited by the art historian Jack Flam, who also wrote *Matisse: The Man and His Art, 1869–1918* (1986).

It was during this shoot that I visited the Chapel of the Rosary in Vence for the first time. That, for me, was a very special moment, as was travelling to New York to interview Picasso's former companion Françoise Gilot about her memories of Matisse. Gilot, an artist in her own right who was by then in her late eighties, was formidable and magnificent: after describing Picasso and Matisse as 'wild beasts', she turned to me and said, 'You know, I'm not tame.' I felt honoured to meet her. 'The first time I saw Matisse, in 1946, he looked like a king in his bed with a beautiful Chinese decoration behind the head of the bed that was purple and black,' Gilot recalled. Her explanation of the artist's genius has stayed with me: 'Matisse was great because he had the audacity of simplicity, always reducing things in the most simple possible way.'

While making the programme, I also met the British painter Howard Hodgkin, with whom I filmed an interview that is available online via the BBC's website. 'I wouldn't be the painter I am if Matisse had never existed,' Hodgkin told me. 'I think he's so great because he realized that when he was painting pictures, he was

making things. They don't depend on the subject matter. They don't depend on visible emotion. They are just themselves. And believe me: that's a very, very difficult thing to do.'

Hodgkin said that he was old enough to remember when people were 'nasty' and 'dismissive' about Matisse's cut-outs: 'It seems impossible to imagine now, but they were.' What did they say? 'That it was sad to see what a great artist had come to in his old age.' Did Hodgkin remember what he thought at the time? 'Yes, I thought what a clever old thing,' he said, and then paused. 'One is left with Picasso's remark, I think, about him: "There was only one Matisse." It's impossible to imagine another one.'

At the end of the interview, Hodgkin lent me his first edition of Alfred Barr's *Matisse: His Art and His Public*, which he could remember reading as a young man over the course of a single weekend, when, he said, it moved him to tears. When I began researching this book, I came across his copy still sitting on my shelf. It's probably about time I gave it back.

A quick note about names: I have followed the convention in much writing about Matisse of calling his models and assistants, such as Lydia Delectorskaya and Jacqueline Duhême, by their first names. This is in no way meant to belittle them or their contributions to Matisse's life and art, but instead to emphasize their family-like intimacy with the artist, for whom they often played essential roles.

Lastly, as well as my agent, Rosemary Scoular, I would like to thank my editor, Ben Brusey, and Donna Poppy at Penguin, whose suggestions immeasurably improved my manuscript, as well as my wife, Katharine, for her patience, intelligent criticism and support.

Alastair Sooke
London
February 2014

Select Bibliography

Barr, Jr, Alfred H. *Matisse: His Art and His Public*. New York: The Museum of Modern Art, 1951.

Elderfield, John. *The Cut-Outs of Henri Matisse*. New York: George Braziller, 1978.

Flam, Jack. *Matisse: The Man and His Art, 1869–1918*. Ithaca, New York: Cornell University Press, 1986.

—. *Matisse and Picasso: The Story of Their Rivalry and Friendship*. Cambridge, Massachusetts: Westview Press, 2003.

— (ed.). *Matisse on Art*. Revised edition. Berkeley and Los Angeles: University of California Press, 1995.

Gilot, Françoise, and Lake, Carlton. *Life with Picasso*. With an introduction by Tim Hilton. London: Virago Press, 1990.

Klein, John. 'Matisse after Tahiti: The Domestication of Exotic Memory', *Zeitschrift für Kunstgeschichte* 60, Bd., H. 1 (1997), pp. 44–89.

Matisse, Henri. *Jazz*. Facsimile edition. With an introduction by Riva Castleman. Text by Henri Matisse. Translated from the French by Sophie Hawkes. New York: George Braziller, 1992.

—, with Courthion, Pierre. *Chatting with Henri Matisse: The Lost 1941 Interview*. Edited by Serge Guilbaut. Translation by Chris Miller. London: Tate Publishing, in association with the Getty Research Institute, Los Angeles, 2013.

Millard, Charles W. 'The Matisse Cut-Outs', *Hudson Review*, Vol. 31, No. 2 (Summer, 1978), pp. 320–27.

Néret, Gilles. *Matisse*. Translated by Lisa Davidson. Paris: Nouvelles Éditions Françaises, 1991. English translation copyright 1993 by William S. Konecky Associates.

Pulvenis de Séligny, Marie-Thérèse. *Matisse: The Chapel at Vence*. Photography by BAMS – Photo Rodella. Translated from the French by Caroline Beamish. London: Royal Academy of Arts, 2013.

Russell, John. *Matisse: Father & Son*. New York: Harry N. Abrams, 1999.

Spurling, Hilary. *The Unknown Matisse: A Life of Henri Matisse. Volume One: 1869–1908*. London: Hamish Hamilton, 1998.

—. 'Debits and Credits: Henri Matisse, the Bussys and Bloomsbury', *Burlington Magazine*, Vol. 147, No. 1225, French Art and Artists (April, 2005), pp. 235–9.

—. *Matisse the Master: A Life of Henri Matisse. The Conquest of Colour: 1909–1954*. New York: Knopf, 2005; London: Hamish Hamilton, 2005.

Exhibition Catalogues (listed chronologically)

Henri Matisse: Paper Cut-Outs. With contributions from Jack Cowart, Jack Flam, Dominique Fourcade and John Hallmark Neff. Published by the St Louis Art Museum and the Detroit Institute of Arts; distributed by Harry N. Abrams, New York, 1977.

Matisse in Morocco: The Paintings and Drawings, 1912–1913. With contributions from Jack Cowart, Pierre Schneider, John Elderfield, Albert Kostenevich and Laura Coyle. National Gallery of Art, Washington. Distributed in Great Britain by Thames and Hudson, London, 1990.

Henri Matisse: A Retrospective. Edited by John Elderfield. New York: The Museum of Modern Art, 1992.

Matisse et l'Océanie: le voyage à Tahiti. Edited by Dominique Szymusiak. Musée départemental Matisse, Le Cateau-Cambrésis, 1998.

Matisse Picasso. With contributions from Elizabeth Cowling, Anne

Baldassari, John Elderfield, John Golding, Isabelle Monod-Fontaine and Kirk Varnedoe. London: Tate Publishing, 2002.

Ils ont regardé Matisse: une réception abstraite, États-Unis/Europe, 1948–1968. Edited by Éric de Chassey and Émilie Ovaere. Musée départemental Matisse, Le Cateau-Cambrésis. Montreuil: Éditions Gourcuff Gradenigo, 2009.

Matisse. La couleur découpée. Une donation révélatrice. Edited by Patrice Deparpe. Musée départemental Matisse, Le Cateau-Cambrésis. Paris: Somogy éditions d'Art, 2013.

Henri Matisse: The Cut-Outs. Edited by Karl Buchberg, Nicholas Cullinan and Jodi Hauptman. With essays by Karl Buchberg, Nicholas Cullinan, Samantha Friedman, Flavia Frigeri, Markus Gross, Jodi Hauptman, Stephan Lohrengel and Nicholas Serota. London: Tate Publishing, 2014.